IMAGES
of America

Amarillo's Historic
Wolflin District

Christine Wyly

IMAGES
of America

AMARILLO'S HISTORIC
WOLFLIN DISTRICT

Christine Wyly

ARCADIA
PUBLISHING

Published by Arcadia Publishing
Charleston, South Carolina

Printed in the United States of America

Library of Congress Control Number: 2010922000

For all general information contact Arcadia Publishing at:
Telephone 843-853-2070
Fax 843-853-0044
E-mail sales@arcadiapublishing.com
For customer service and orders:
Toll-Free 1-888-313-2665

Visit us on the Internet at www.arcadiapublishing.com

*This book is dedicated to the memory of Charles Alexander Wolflin,
who never gave up on his dreams.*

CONTENTS

ACKNOWLEDGMENTS

My deepest appreciation goes to my parents and grandparents for instilling in me a sense of heritage and love of history. I am especially grateful to Travis Crowell and Wagner's Photography, who skillfully reproduced the photographs for this book. Gratitude also goes to Rob Groman at the Amarillo Public Library for his assistance, as well as to Betty Howell, who provided me with invaluable research data. Thanks go to Abbie Flowers for the loan of her camera for the handful of modern photographs included in this book. Others who helped and encouraged me are Hugh Wayne Stevens, Nancy Lindsey, Deborah Hornsby, Kathy Davis Guthrie, the Amarillo Association of REALTORS, Helen Benton, Jayne Brainard, Charles Johnson, Dr. Jack and Sandra Waller, Pattilou Dawkins, Gretchen Wolflin Izett, and Jane Juett. Most of all, what I loved the most about this project was the many hours I spent on sofas and at dining room tables listening to stories of families and the lives of those who have gone before us. I will always remember the input of pioneer families and other residents as lovely and gracious acts of kindness.

INTRODUCTION

Visitors to the Texas Panhandle are first struck by the treeless wide-open spaces and the grandeur of the big sky. The High Plains has a hard edge, a harshness, but the landscape is dotted with surprises like the Palo Duro Canyon, the Canadian River, and magnificent sunrises and sunsets. The people who settled the Llano Estacado (the Staked Plains) came looking for land and the hope of better lives for themselves and their families. They were met with wind and grit, loneliness, and hardship. The population has endured fires, tornadoes, drought, dust storms, and the Great Depression. Wars, deep recessions, and oil booms and busts have not deterred the people who have toughed it out since Amarillo was founded. Those who stayed have created and maintained a thriving city with a varied economic base as well as racial and cultural diversity. The pioneer heritage of hard work, cooperation, public service, and philanthropy has been the foundation Amarillo was built on.

Amarillo, Texas, was established by merchants in 1887 close to a large playa lake known as Amarillo, or Wild Horse Lake. On August 30, 1887, it was officially chosen to be the Potter County seat and became the region's main trade center with help from the building of railroads. The railroad is still an important facet of Amarillo commerce, in part because Amarillo has been one of the world's busiest cattle shipping points since 1890. Amarillo is a major transportation point for trucking and railroads that ship beef, diary products, and manufactured goods throughout the United States.

Historically, Amarillo's industry and commerce has centered on ranching, farming, and oil and gas exploration and production; however, during World War II and until the late 1960s, the area's economy was shored up by the Amarillo Air Force Base, located east of the city. When the facility closed, a portion of the base was used as part of what is now known as the Rick Husband Amarillo International Airport. The original runway of the air base is now the longest commercial runway in the United States, which helps keep Amarillo on airline routes and schedules. Because of its length and centralized location, the runway is a secondary landing location for NASA's space shuttle in case of emergency, and private jets use it for refueling stops on cross-country trips.

In recent years, diversification of industry has kept Amarillo alive and growing. The agricultural industry has expanded to include large diary farms coupled with cheese manufacturing. It is a city with petroleum exploration businesses, nationwide call centers, and international distribution warehouses. Today Amarillo is home to a Bell Helicopter assembly plant for the Osprey aircraft, the Amarillo Copper Refinery, a Tyson Fresh Meat plant, an Owens-Corning Fiberglass plant, the Pantex nuclear weapons plant, and state-of-the-art medical facilities that attract clientele from the surrounding rural Texas Panhandle, New Mexico, Oklahoma, and Kansas areas.

Amarillo, at the center of the High Plains, has been called the crown of the Texas Panhandle. The Wolflin Historic District is the jewel in the crown, near the geographical center of the city. The Wolflin area is now thought of as the central part of Amarillo, but when it began, it was still very much a rural area. An early addition to Amarillo, the first sections of Wolflin were platted in the mid-1920s. It is known for its architecture, tree-lined brick streets, and lush landscapes.

After T. J. Wagner and Col. Will A. Miller Jr. initially purchased 80 acres from the Wolflin family and began development of Wolflin Place, progress stagnated due to a lack of pavement and utilities. However, in 1926, Amarillo became an oil and gas boomtown, cash became available, and the subdivision began to spread again. At that time, the Wolflin family sold an additional 40 acres to Wagner and Miller, and Charles A. Wolflin worked for them to help in the development. Later, in 1927, the Wolflin family, with Charles at the helm, opened Wolflin Estates, a planned development with larger building sites, curved brick streets, and massive plantings of Siberian elm trees.

About the time development seemed to take off in the late 1920s, the Great Depression started, and the Dust Bowl days began. Growth for Wolflin Park and plans for Wolflin Estates almost halted in the face of severe economic hardship for both residents and developers. The Wolflin family, including Charles A. Wolflin, rolled up their sleeves, found work, and held on. Most of the population struggled, but revenue from the newly discovered oil and natural gas fields in the Texas Panhandle flowed into the bank accounts of some families who had been talented and lucky enough to be in the right place at the right time. Those families still bought homes, and some oil and gas operators with cash, like Tom Currie, bought lots in the Wolflin additions to help service the paving lien assessments by the City of Amarillo.

World War II changed Amarillo, like it did the rest of the nation. After the war, veterans with G. I. Bill–funded educations, new careers, and government-backed home mortgage loans were largely responsible for an economic resurgence in the United States. Amarillo was no exception, and the Wolflin Historic District experienced a building boom during that era. Wolflin Place and especially Wolflin Estates were marketed as premier residential communities. Development was primarily residential rather than commercial. Deed and covenant restrictions protected against encroachments from the hustle and bustle of disagreeable trade activity. This aspect of the planned community insulated the addition from the outside world and added to the residents' confidence that nice homes could be constructed without undesirable buildings being located nearby. The concept was successful because the area became everything the planners had dreamed of and more. Charles A. Wolflin lived until 1991—long enough to learn that the development he had dreamed of had been nominated to be placed on the National Register of Historic Places.

The location, historic qualities of the homes, and the beauty of the tree-lined brick streets makes the Wolflin Historic District an attractive place to live. There are many styles of homes, but the flow of the neighborhood is not broken by the randomness of unique styles because brick streets and stately elm trees provide continuity throughout the subdivision. The shady avenues attract charitable walks in the warmer months. In the winter time the neighborhood has been a Christmas wonderland for many residents of Amarillo, who visit in automobiles, wagons, and carriages. The magnificent Christmas lighting at many of the homes and the U.S. flags flying to commemorate the Fourth of July and Memorial Day are just some of the neighborhood displays of community involvement.

Often residents of the Wolflin Historic District have been the movers and shakers in Amarillo, bringing industry, fine arts, and capital to the city. The allure of the Wolflin Historic District is more than its charm and elegance. The spirit of the Wolflin Historic District is a reflection of the pioneer spirit of Amarillo.

(Portions of the above were excerpted from the author's blog, *Amarillo Hometown by Christine Wyly*, in posts dated March 19, 2008, and June 18, 2008, at www.christinewyly.blogspot.com.)

One

THE WOLFLINS

The Wolflin Historic District started with a love story. Pattilou Dawkins, granddaughter of Charles Oldham Wolflin and Alpha "Alphie" Eunice McVean Wolflin, tells the story of Charles taking Alphie to what is now the intersection of Wolflin Avenue and Washington Street and proposing with a bold statement: "I have two desires in my life—you and that section of land." Dawkins said, "My grandmother gave both to him."

Charles and Alphie married in 1897 and acquired the section of land in 1898 with the financial help of Alphie's mother, Calpurnia Alexander McVean. The Wolflins operated the Daylight Dairy and raised their three children near the present location of Wolflin Elementary School. In 1923, they sold 80 acres in the northeast corner of the section to T. J. Wagner and Col. Will A. Miller Jr., who named it Wolflin Place after the informal name of the original Wolflin dairy farm. That sale began the development of the Wolflin subdivisions as known today.

When Charles O. Wolflin passed away in 1924, his son Charles Alexander Wolflin assumed the management of the Wolflin farming and business interests for his mother but still managed to acquire a bachelor's degree in agriculture from the University of California at Davis. In later years, he mused that he would have been better off obtaining a business degree to prepare him for developing and selling real estate.

Charles A. Wolflin developed Wolflin Estates and Wolflin Park and started the Wolflin Village shopping center in 1953. His oldest sister, Cornelia Wolflin Patton, named the streets in the area now known as Wolflin Terrace after trees such as Locust, Hawthorne, and Juniper. Cornelia was a fun-loving, well-read, educated woman who was a founder, along with Oma Link Rowley, of the Amarillo Little Theatre. The youngest Wolflin child, Lela, obtained a home economics degree and is remembered as a gracious hostess who loved to entertain and as a mother who welcomed the neighborhood children into her home.

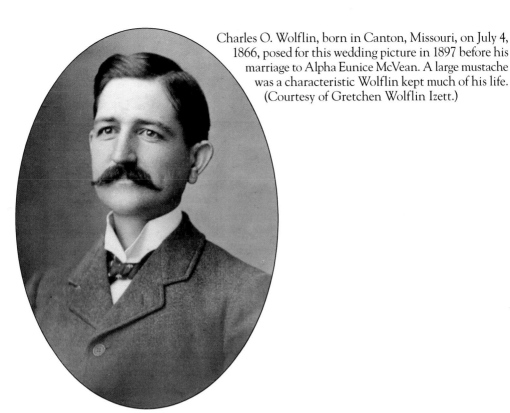

Charles O. Wolflin, born in Canton, Missouri, on July 4, 1866, posed for this wedding picture in 1897 before his marriage to Alpha Eunice McVean. A large mustache was a characteristic Wolflin kept much of his life. (Courtesy of Gretchen Wolflin Izett.)

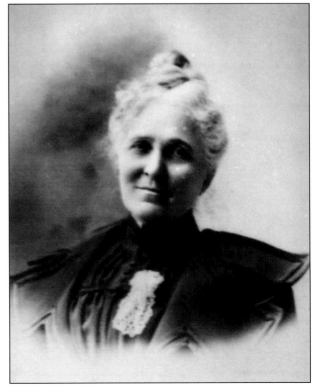

This faded portrait of Alpha E. Wolflin's mother, Calpurnia Alexander McVean, obscures the image of the cultured woman whose largess enabled the newly wed Charles O. Wolflin to acquire the section of land that came to be known as Wolflin Place. McVean, a Missouri widow, was known to be an educated, practical businesswoman who was respected in her community. (Courtesy of Pattilou Dawkins.)

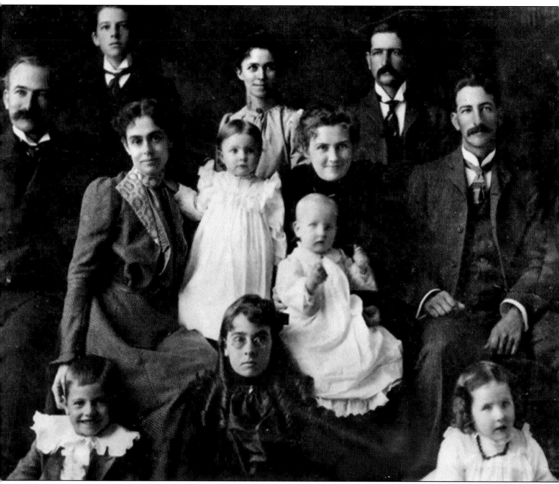

Charles O. Wolflin and his brothers Franklin "Frank" Wolflin and George Hugh Wolflin are pictured with their family in 1901. From left to right are (first row) George "Lewis" Wolflin and Mary "Isabel" Wolflin (son and daughter of George H. and Mary "Lena" M. Wolflin) and Virginia Wolflin (daughter of Frank and Orlena T. Wolflin); (second row) Mary "Lena" Maupin Wolflin (wife of George H. Wolflin), Cornelia Wolflin (daughter of Charles O. Wolflin and Alpha E. Wolflin), Orlena Thompson Wolflin (wife of Frank Wolflin) holding daughter Lee Wolflin, and Frank Wolflin; (third row) George H. Wolflin, Hugh M. Wolflin (son of George H. and Mary "Lena" M. Wolflin), Alpha Eunice McVean Wolflin (wife of Charles O. Wolflin), and Charles O. Wolflin. (Courtesy of Gretchen Wolflin Izett.)

Capitalizing on the Fort Worth and Denver Railroad route through Amarillo, brothers George H., Charles O., and Frank Wolflin opened a mercantile store in 1891 at Fifth and Polk Streets. The Canton, Missouri, natives had previously lived near Gainesville, Texas, and had worked in central and northern Texas counties on ranches and surveying crews. Frank moved to Amarillo first in 1890 to build the store. He lived in a boardinghouse during the construction of the store and moved to living quarters above the store when it was completed. All three Wolflin brothers had an interest in the store until 1903, when George sold his interest to Frank and moved to Arizona for health reasons. The store was subsequently sold when Frank went to work as the Potter County clerk. (Courtesy of Gretchen Wolflin Izett.)

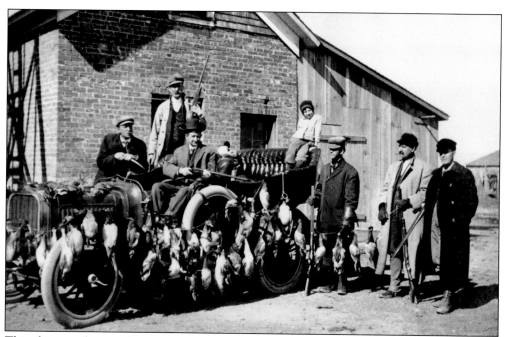

This photograph was taken on the Wolflin farm after a duck hunt. Charles A. Wolflin, born in 1902, is the child perched atop the seat in the vehicle. Posing from left to right are Tom Currie, a Dr. Wood, L. O. Thompson, Charles A. Wolflin (on seat), Gen. Earnest O. Thompson, Charles O. Wolflin, and D. W. Owen. (Courtesy A. C. "Bub" Smith.)

In this 1900 photograph, Charles O. Wolflin is pictured in the driver's seat of a vehicle prior to his departure on a business trip from Amarillo to Fort Worth, Texas. Wolflin, accompanied by a delegation of other businessmen, was a keen promoter of development in Amarillo. (Courtesy of Pattilou Dawkins.)

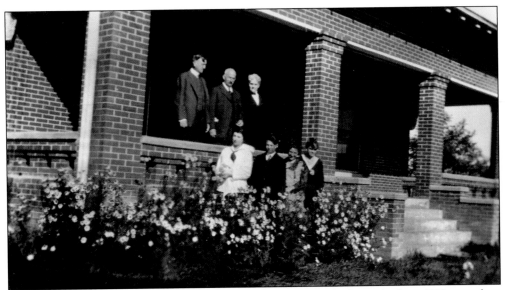

In this *c.* 1916 photograph, Wolflin family members gather at the home built in 1910 to replace the original farmhouse on Wolflin Place. Standing on the porch are, from left to right, Charles O. Wolflin, his brother George H. Wolflin, and their half sister Louise Lewis. The children in front of the house are, from left to right, Cornelia Wolflin, Charles A. Wolflin, Lela Wolflin, and Carrie Edwards (granddaughter of Louise Lewis). (Courtesy of Gretchen Wolflin Izett.)

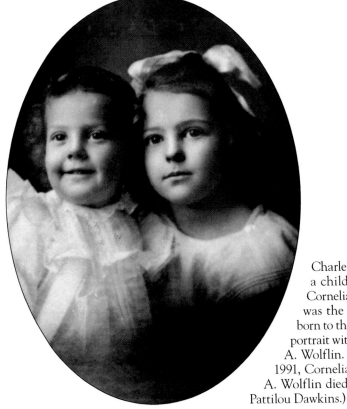

Charles O. and Alpha E. Wolflin lost a child who was stillborn in 1898. Cornelia Wolflin (right), born in 1900, was the oldest of two daughters later born to them. She is pictured in this early portrait with her younger brother Charles A. Wolflin. Almost 90 years later, in July 1991, Cornelia Wolflin Patton and Charles A. Wolflin died just days apart. (Courtesy of Pattilou Dawkins.)

The children of Charles O. and Alpha E. Wolflin are pictured in this portrait, thought to be from 1912. The young people, from left to right, are Lela McVean Wolflin Puckett, Cornelia Wolflin Patton, and Charles A. Wolflin. (Courtesy of Pattilou Dawkins.)

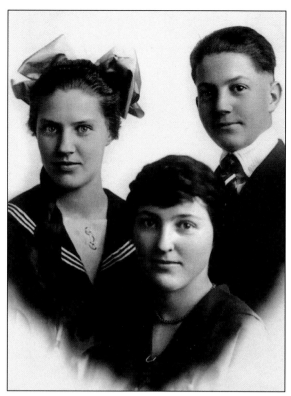

Lela McVean Wolflin Puckett, born in 1904, was the youngest child of Charles O. and Alpha E. Wolflin. This portrait was taken in 1920, when she was 16 years old. She later married Louis Hunter "Cedar" Puckett, an oil and gas broker and independent oil operator, in 1928. They raised their family at 2614 Hayden Street in Wolflin Place until moving to 3 Greenwood Lane in Wolflin Park. (Courtesy of Pattilou Dawkins.)

Cornelia Wolflin Patton, oldest daughter of Charles O. and Alpha E. Wolflin, is pictured at left as a young woman. She persuaded others in the Wolflin family to donate a strip of land at Wolflin Avenue and Austin Street to be dedicated as a nonprofit area. That strip of land is still home to the Amarillo Little Theatre today. (Courtesy of Pattilou Dawkins.)

Cornelia Wolflin appears to be in costume in this photograph. She loved the theater, directed plays, and founded the Dramateens. In September 1923, she entered the Pageant of the Plains as Miss Wolflin and was crowned the first Queen of the Plains at the first Amarillo Tri-State Exposition. (Courtesy of Pattilou Dawkins.)

This portrait of Charles O. Wolflin, who died in 1924 of a heart attack, hangs in Wolflin Elementary School. His obituary described him as a pioneer businessman whose pallbearers were John McKnight, C. D. Hoover, S. F. Newbold, B. S. Arnold, Charles Ware, E. F. Granberry, Jack Wheatley, and Thomas Currie. Honorary pallbearers included W. Boyce, B. T. Ware, Dr. R. S. Killough, J. J. Currie, L. O. Thompson, P. H. Landergin, W. H. Fuqua, R. E. Underwood, and M. C. Nobles. (Courtesy of Gretchen Wolflin Izett.)

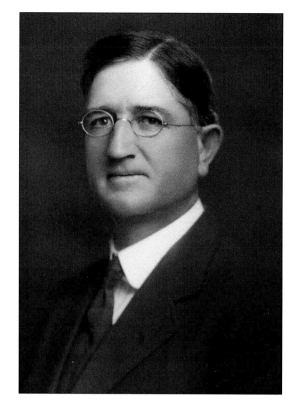

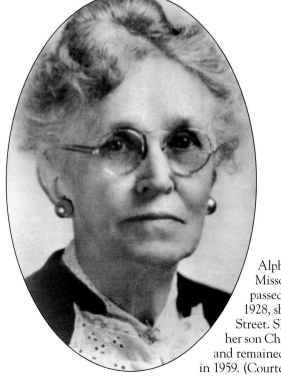

Alpha E. McVean Wolflin was born in Tipton, Missouri, and never remarried after her husband passed away. She remained in Amarillo, and in 1928, she moved to a stately home at 2800 Hughes Street. She was "Alphie" to her family, worked with her son Charles A. Wolflin to develop Wolflin Estates, and remained active in other family business. She died in 1959. (Courtesy of Gretchen Wolflin Izett.)

17

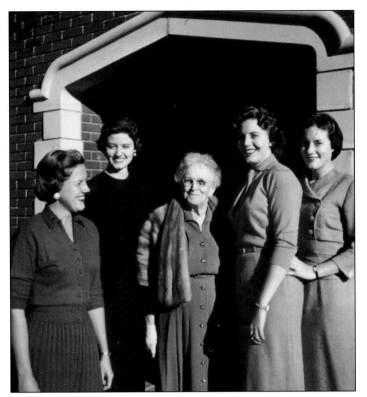

A beloved grandmother, Alphie poses in front of the Puckett family home at 3 Greenwood Lane with her granddaughters for this 1950s photograph. Pictured from left to right are Fain Wolflin Ent, Gretchen Wolflin Izett, Alpha E. Wolflin, Nancy Puckett Berry, and Pattilou Puckett Dawkins. (Courtesy of Pattilou Dawkins.)

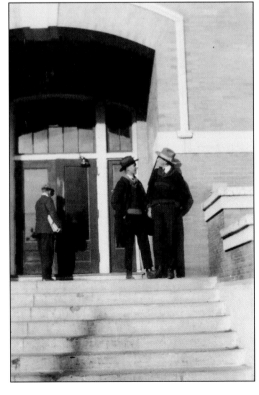

Charles A. Wolflin (right) was a personable man who picked up the mantle passed on by his father, Charles O. Wolflin, and transformed the family land from the Daylight Dairy and Farm into a grand residential development. Here he visits with an unidentified man on the steps of Wolflin Elementary School, possibly while waiting for his future wife, Grace Fain, who taught first grade there until 1930. (Courtesy of Pattilou Dawkins.)

An early home in the Wolflin Place addition was the Charles A. Wolflin home at 2037 South Hughes Street. The home was built in 1927 by Hugh Underwood and was first lived in by Charles B. Cozart. The Wolflin family lived in the house from 1931 until 1948. The house was eventually torn down and replaced with a commercial building. (Courtesy of Gretchen Wolflin Izett.)

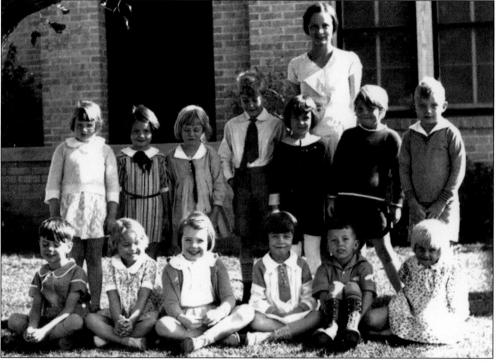

Grace Wolflin operated a private first grade in her home from 1931 to 1933 to supplement the family's income during the Depression. Her five-year-old students in 1931 are, from left to right, (first row) Jack Shelton, LaVerna Nelson, Peggy Lynn, Barbara Boyce, O. D. Thompson, and Saranne Smith; (second row) Connie Fuqua, Elaine Johnson, Joy Florey, Larry Oles, ? Levine, Georgia Lou Mode, and unidentified. (Courtesy of Nita Johnson Griffin.)

Charles A. Wolflin administered the Wolflin Estates Development Company and the Wolflin Mortgage Company. He developed the Wolflin Village shopping center and was involved with building the LaTour Apartments. His other accomplishments include helping to open the Federal Housing Administration (FHA) loan department of Amarillo National Bank during the Depression, serving on various boards for the City of Amarillo, and serving as president of the Amarillo Real Estate Board in 1930 and 1951. He volunteered on the Community Chest Board, and later in life he served as an elder and trustee at First Presbyterian Church, where he had been a member since 1914. (Courtesy of Pattilou Dawkins.)

Two

DEVELOPMENT

Suburbs in the early 20th century were greatly affected by the invention of the automobile. Widespread use of the automobile changed the composition of developing neighborhoods both physically and socially. New developments in the 1920s were planned with the use of curbs and driveway openings for automobiles rather than the previous use of uninterrupted curbs. Wolflin Place, an early example of this trend, was one of the first local developments where driveway openings were used.

Streetcar use had previously necessitated residential designs laid in grid patterns. Easily built and less costly grid patterns on level terrain were the norm in the beginning of the 20th century. The layout of Wolflin Estates followed a shift from the standard layout of suburbs in Texas when the Wolflins engaged Hare and Hare, a Kansas City landscape architectural firm, to provide the design for the new addition in 1927.

The configuration of Wolflin Estates followed a new trend similar to the landscape plans in Dallas and Houston, which followed lines along natural and man-made features and landmarks. This more affluent curvilinear street network that followed topographical contours was used in the Wolflin Estates design rather than the standard 19th-century grid. Hare and Hare proposed other landscaping features, such as small parks, wide streets, and a traffic circle, which were adopted as well. The services of Hare and Hare and the incorporation of the features they proposed were more costly than standard residential development expenditures. Consequently, the more affluent the suburb, the more likely the firm's services were used and their proposals were adopted.

This aspect of the Wolflin Estates played into the promotion by the Wolflins, who advertised the addition as "A Spacious Setting for Fine Homes." The image of Wolflin Place and Wolflin Estates with tree-lined, brick-paved, curving streets still benefits from the careful planning of the Wolflin family and the recommendations by Hare and Hare in 1927. The Wolflin area is known as a lovely subdivision with an affluent appearance—a desirable neighborhood for professionals, prominent citizens, and wealthy descendants of early area settlers.

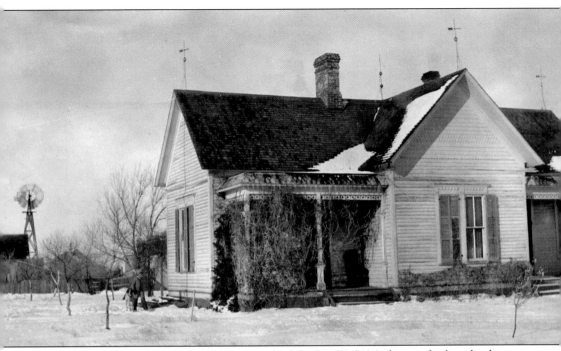

The first home in the Wolflin addition was built by Dr. W. C. Mathews, who bought the section of land from J. T. Berry in 1889. Dr. Mathews died in 1892. Struggling with the mortgage, his widow, Maggie F. Mathews, sold out to Alpha E. Wolflin in 1898. Much of the section was pastureland used for grazing cattle in the family dairy operation. The seven-room house was located at approximately 2032 Washington Street, at the northeast corner of the section. The milk house and windmill were just south of the present-day location of the Wolflin Elementary School. Charles O. and Alpha E. Wolflin's children, Cornelia Wolflin Patton, Charles A. Wolflin, and Lela Wolflin Puckett, were born in the house. The boy tromping through the snow in this photograph is Charles A. Wolflin at age eight or nine, coming back from the barn with his dog, Bob. (Courtesy of Gretchen Wolflin Izett.)

In 1910, Charles O. Wolflin replaced the old Mathews homestead and built a brick home for his family, who moved there in 1911. The new home, similar to the Sears and Roebuck kit homes built in the United States, was a relatively grand home at the time. The house was built at the northeast corner of the Wolflin farmland near where the Wolflin Drive-In was located in the 1960s. (Courtesy of Gretchen Wolflin Izett.)

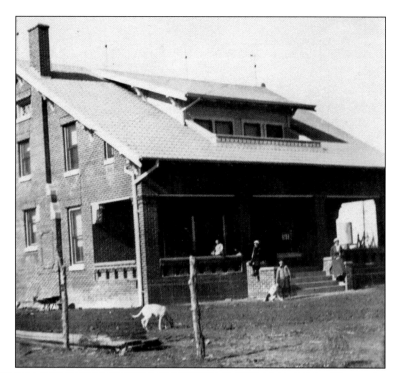

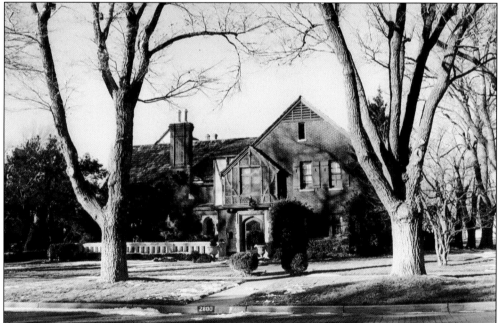

The home at 2800 South Hughes Street in Wolflin Estates, designed by architect Emmett F. Rittenberry in 1928, was used for homesite sales promotions in the new addition. Alpha E. Wolflin hired contractor Frank Jesse to build the palatial Tutor Revival–style home and engaged Charles Keith Furniture and Carpet Company in Kansas City, Missouri, to create the interior. Today the home is owned by an Amarillo physician and has been impeccably preserved to stand as a beautiful monument to the Wolflin family. (Photograph by Christine Wyly.)

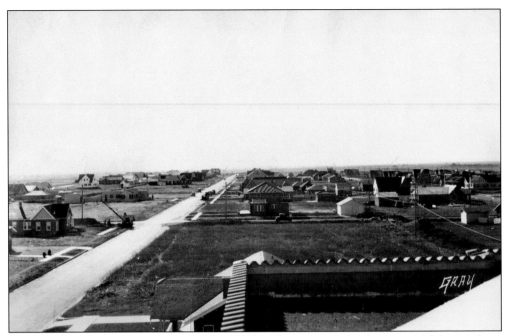

The view from the southeast corner of the Wolflin Elementary School rooftop looking south on Hughes Street in 1927 illustrates the progression of the Wolflin Place development. The pavement in the new development was only completed to about the 2200 block of the first four streets in the new subdivision. Those first four streets were Washington, Hughes, Hayden, and Ong Streets. (Courtesy of Pattilou Dawkins.)

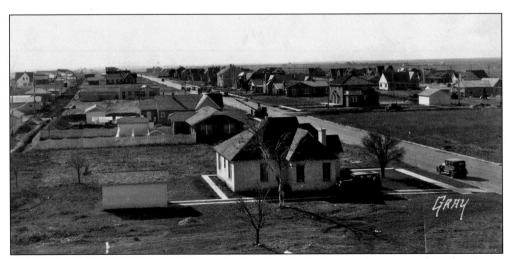

This 1927 aerial photograph, taken from the top of a windmill, provides a view of Hughes Street looking from the 2000 block south toward Twenty-first and Twenty-second Streets, with open prairie beyond. Construction workers and machinery can be seen in the vicinity of 2037 Hughes Street, the future home of the Charles A. Wolflin family. (Photograph by Gray's Studio; courtesy of Gretchen Wolflin Izett.)

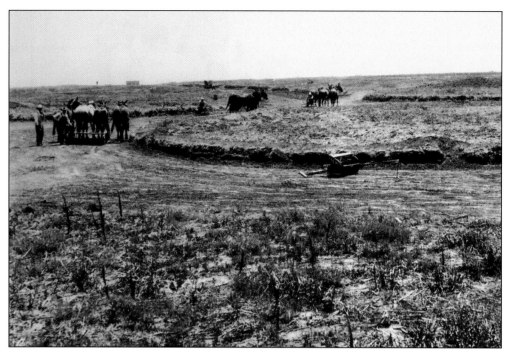

This 1920s image shows mule teams cutting Oldham Circle out of the Wolflin family's pasture. Driving around Oldham Circle today, it is hard to imagine that before the establishment of the development the scene was this vast barren landscape. (Courtesy of Pattilou Dawkins.)

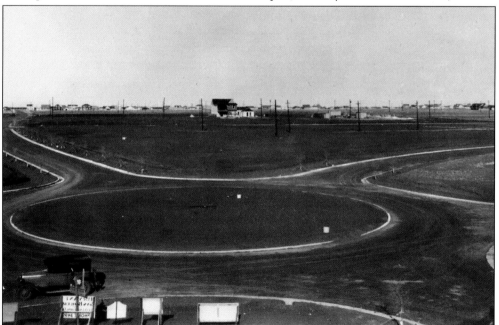

This 1928 view of a developing Oldham Circle is thought to be a northeast view looking back toward Wolflin Place and the Oliver-Eakle addition. Note the differences from the previous picture, such as the presence of curbs and the leveled homesites. Today Oldham Circle is arguably one of the most elegant streets in Amarillo. (Courtesy of Pattilou Dawkins.)

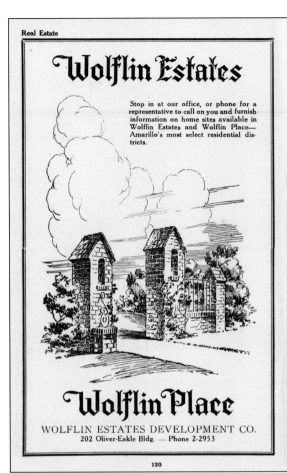

Wolflin Estates

Stop in at our office, or phone for a representative to call on you and furnish information on home sites available in Wolflin Estates and Wolflin Place—Amarillo's most select residential districts.

Wolflin Place

WOLFLIN ESTATES DEVELOPMENT CO.
202 Oliver-Eakle Bldg. — Phone 2-2953

120

The Wolflin Place and Wolflin Estates residential homesites were tastefully advertised in city directories early in the development phases. The Wolflin Estates Development Company office was located at 602 Polk Street downtown in the 1927 Oliver-Eakle Building, an early high-rise office building in Amarillo. (Courtesy of Betty Howell.)

Steamrollers were used to pack down earth on the streets in the new development. Looking north, this image of crews using various modes of equipment to work on a street and to build numerous new homes in Wolflin Place demonstrates the pace of the creation of a new neighborhood. (Courtesy of Pattilou Dawkins.)

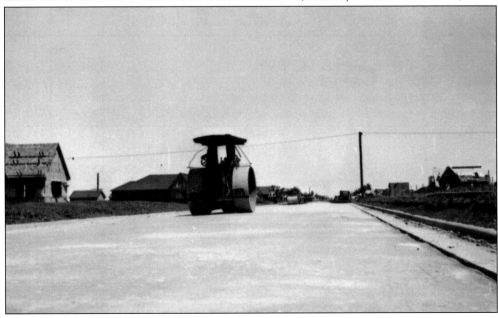

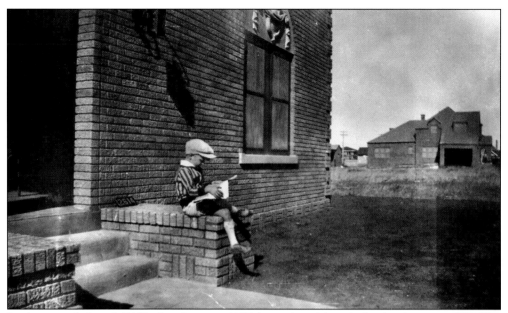

Looking north from 2614 Hughes Street in 1927 shows that although the development of Wolflin Place progressed southward at a steady pace prior to the Depression, vacant lots were still available. The child pictured in front of the home is Ray C. Johnson Jr. (Courtesy of R. C. "Charles" Johnson III.)

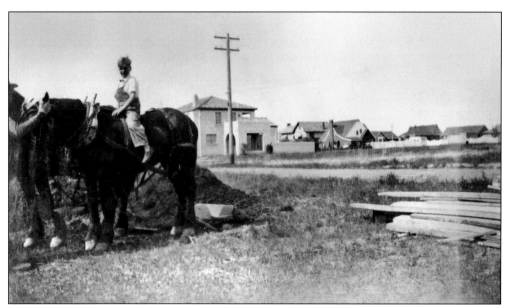

Mules were still used in construction in the late 1920s. The mule team in this image was put into service to help move material to build 2615 Hayden Street in 1929. The homes across the alley in the background are in the 2600 block of Hughes Street. Ray C. Johnson Jr. is the boy sitting atop the mule. (Courtesy of R. C. "Charles" Johnson III.)

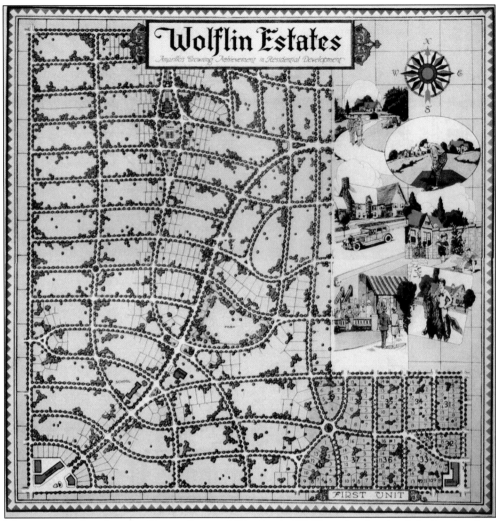

This map was found in the filing cabinet of Charles A. Wolflin after his death by his daughter Gretchen Wolflin Izett. She reproduced the map and distributed it among her siblings and cousins. The first unit of Wolflin Estates is clearly marked on the map Wolflin used to promote new lots in the upscale development. The map is a beautiful colored rendition of Wolflin's vision for the development. Izett calls it the map of dreams and reminds her family of the hard times the family went through during the Depression. Further, she shared with each of her family members in a letter accompanying their copy of the map the fact that Wolflin never lost sight of his dreams while trying to save the property during the Depression. (Courtesy of Gretchen Wolflin Izett.)

This city directory advertisement for Wolflin Estates lots extolled the merits of broad, brick-paved streets and announced the benefits of fine living in a beautiful, upscale residential area. The new planned development was a progressive concept in the 1920s and required enticing promotion. (Courtesy of Betty Howell.)

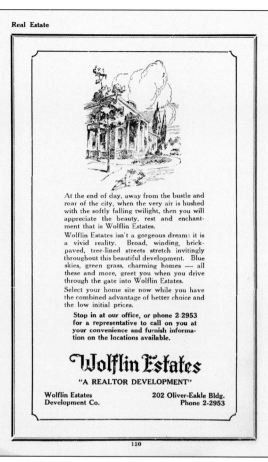

Real Estate

At the end of day, away from the bustle and roar of the city, when the very air is hushed with the softly falling twilight, then you will appreciate the beauty, rest and enchantment that is Wolflin Estates.

Wolflin Estates isn't a gorgeous dream: it is a vivid reality. Broad, winding, brick-paved, tree-lined streets stretch invitingly throughout this beautiful development. Blue skies, green grass, charming homes — all these and more, greet you when you drive through the gate into Wolflin Estates.

Select your home site now while you have the combined advantage of better choice and the low initial prices.

Stop in at our office, or phone 2-2953 for a representative to call on you at your convenience and furnish information on the locations available.

Wolflin Estates
"A REALTOR DEVELOPMENT"

Wolflin Estates 202 Oliver-Eakle Bldg.
Development Co. Phone 2-2953

120

The view in this 1928 image looking northwest shows Lipscomb Street curve away from Oldham Circle at Thirty-second Avenue toward Thirtieth Avenue. The contrast of the steamroller working alongside the mule team preparing the street for paving illustrates the transition from a literal horsepower era into the mechanized age. (Photograph by Gray's Studio; courtesy of Pattilou Dawkins.)

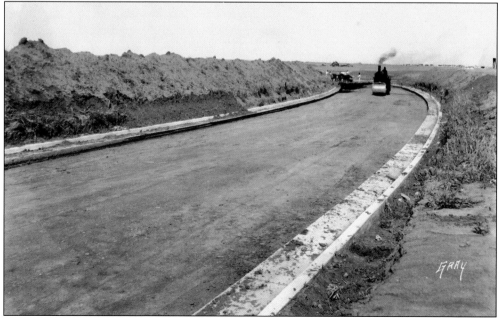

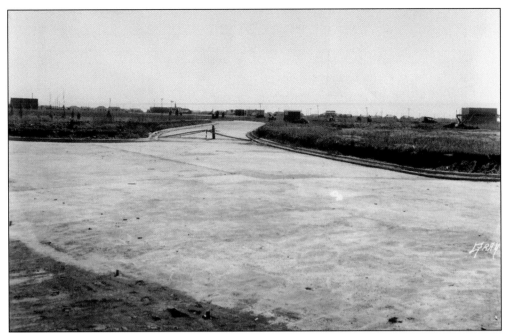

Looking southeast from the intersection of Hayden Street and Thirty-second Avenue shows the new park on the left and the surrounding new construction in 1927. The triangle-shaped park between Hughes and Hayden Streets, bounded by Thirty-second and Thirty-third Avenues, was part of the promotion of the new neighborhood as a place of green grass, beauty, and rest. (Photograph by Gray's Studio; courtesy of Pattilou Dawkins.)

The same view as above shows the park and surroundings in 1929. Of note is the presence of young trees and completed construction. Thirty-third Avenue, in the center of the picture, curved out of the subdivision toward Washington Street. The broad curving streets were a new look for Amarillo neighborhoods in the 1920s. Prior developments had been laid out in grid patterns from north to south and east to west. (Courtesy of Pattilou Dawkins.)

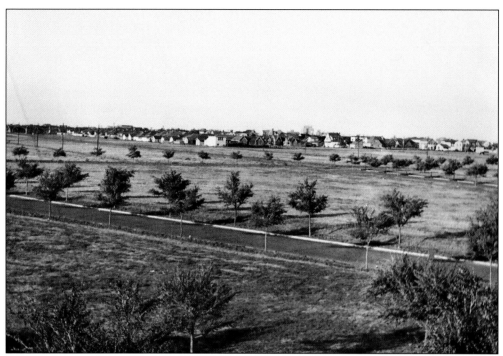

In this 1929 panoramic view looking northeast toward the developing Wolflin addition, the progression from north to south is evident and Lipscomb Street is clearly visible in the foreground. One of the more interesting aspects of this image is the rows of two-year-old trees in their early stages of growth. The trees, Siberian elms, are a hallmark feature of the Wolflin neighborhood today. (Courtesy of Pattilou Dawkins.)

New trees and new homes in the Wolflin Estates development can be seen in this 1929 picture looking north along Hughes Street from near Thirtieth Avenue. Two-year-old trees line the street in front of the homes, which are, from left to right, 2816 Hughes, 2806 Hughes, and 2800 Hughes Street. (Courtesy of Pattilou Dawkins.)

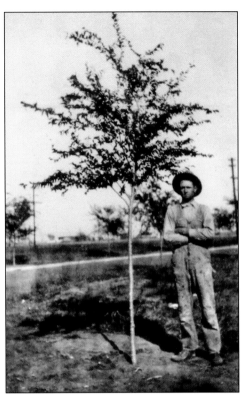

The picture at left shows an unidentified man standing next to a typical 8- to 10-foot Siberian elm after one year of growth. The picture below places the same man next to a Siberian elm after two years of growth. Wolflin Estates was a planned development that started with a barren prairie, thus trees were of great importance. The tree rows attracted residents to the homesites because they blocked the Panhandle wind, provided shade, and created a park-like atmosphere. Charles A. Wolflin's foresight in planting 1,000 trees at the cost of $1 each made the neighborhood more desirable. The difficult undertaking of frequent watering using a mule-drawn water wagon has proven to be a worthwhile sacrifice. The stately elms still live in the Wolflin Historic District today and provide character to the area that is unmatched elsewhere in Amarillo. (Both courtesy of Dusty McGuire.)

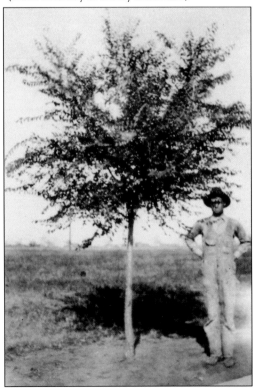

In 1932, the immature landscape of 2406 Lipscomb Street appeared to be sparse against the backdrop of the High Plains. The above photograph shows the Siberian elms planted by the developers of Wolflin Place, as well as plantings of trees and shrubs within the yard and along the property lines by the homeowner, Lawrence Hagy. In the picture below, the June 1951 appearance of mature landscaping illustrates the beauty of long-range landscape planning by the developers and residents of Wolflin subdivisions. Shade is a desirable asset for any Texas Panhandle home, but Wolflin homes are especially known for their shady location in a park-like setting. (Both courtesy of the Lawrence Hagy estate.)

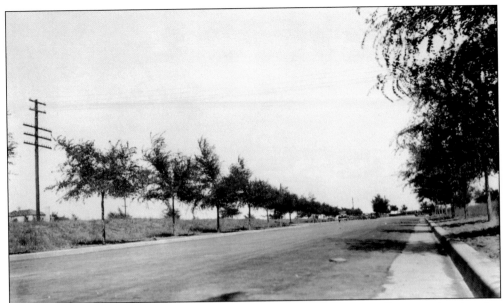

This 1929 ground-level view of Ong Street, close to Thirtieth Avenue, illustrates the planning involved in having trees in place before selling homesites in Wolflin Estates. Curbs and gutters were also in place and added to the pre-finished look of the developing subdivision. The "charming home" concept in the Wolflin Development Company's advertising was more credible when prospective buyers saw pre-existing infrastructure, in turn making lots more marketable. (Courtesy of Pattilou Dawkins.)

This late-1920s or early-1930s view northward across the park at Thirty-second Avenue and Hughes Street shows the establishment of grass and shrubbery. Hoses and sprinklers were used to water the new plantings in the triangular-shaped park. The homes in the background are thought to be in the 3000 block of Hughes and Hayden Streets. (Courtesy of Pattilou Dawkins.)

Another view from the park at Thirty-second Avenue and Hughes Street gives a closer look at Hughes Street. The sprinklers and hoses are visible on the new lawn in the park. In the background on the left is the C. W. Furr home, built in 1930, at 3006 Hughes and a new home under construction on the right. (Courtesy of Pattilou Dawkins.)

The north end of the park at Thirty-second Avenue and Hughes Street offers an early glimpse down Hughes Street. This ground-level photograph provides a clear perspective of the orderly planting of Siberian elms alongside the street. (Courtesy of Pattilou Dawkins.)

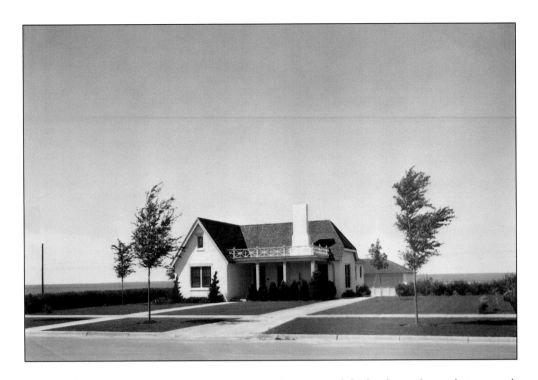

Pictured above in 1933, the home at 2406 Lipscomb Street and the landscape beyond give a stark picture of the delineation between development and open prairie in the early 1930s. Lipscomb Street was the street farthest west in Wolflin Place and Wolflin Estates until the end of World War II. Development on Parker Street, the next street west of Lipscomb Street, began on the north end in about 1945 and progressed southward. The 3000 block of Parker Street in Wolflin Estates also began to have some development in the 1940s. Below, an image of the same home in August 1939 shows development of the landscape, an addition of a fence, and the presence of neighbors. (Both courtesy of the Lawrence Hagy estate.)

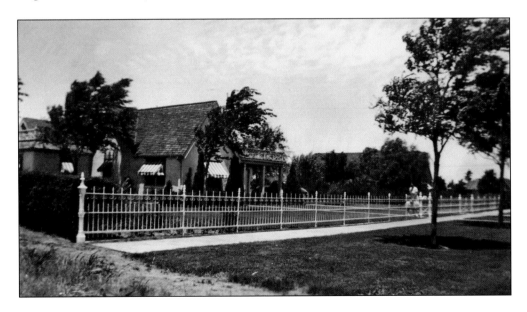

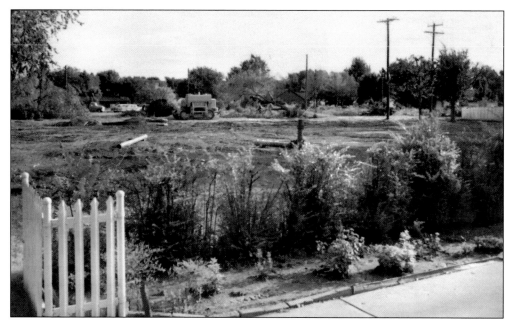

This area on the northeast outside edge of the Wolflin Historic District was drastically changed in the mid-1960s. The excavation of this lot was related to the construction of Interstate 40, which was completed in 1966. It was built just two blocks north of the district but did not directly affect Wolflin Place or Wolflin Estates; however, the surrounding commercial area where residents shopped and conducted business was irrevocably altered. (Courtesy of Wagner's Photography.)

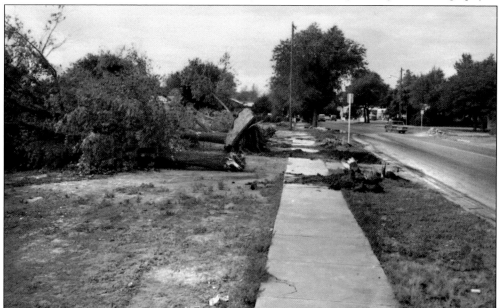

Washington Street, the eastern border of the Wolflin Historic District, was widened in the 1960s. This southbound view of the street during construction shows the removal of Siberian elm trees planted by the Wolflins in the 1920s. The upheaval of the massive tree roots reveals a remarkable contrast between the first pictures of the trees planted in the district and this picture 40 years later. (Courtesy of Wagner's Photography.)

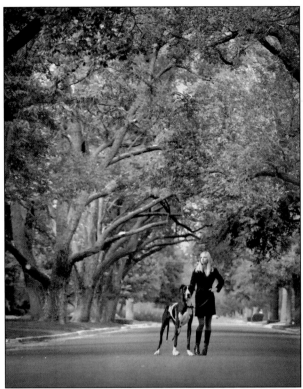

This picture of Candace Crowell and her dog, Brutus, was taken in the late summer of 2009 in the 2800 block of Hayden Street. The unique, professionally focused photograph highlights the magnificent canopy of trees that embraces the Wolflin Historic District today. (Courtesy of Wagner's Photography.)

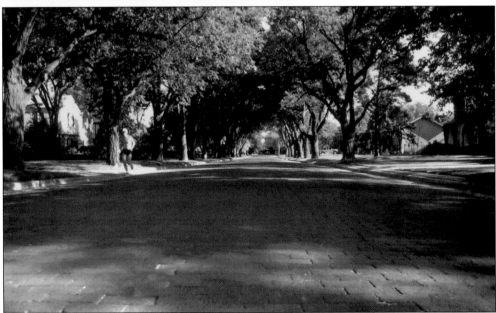

The undated photograph above, taken from near ground level, gives the appearance of a Wolflin brick street rising to meet the camera with a tunnel of trees in the background. These cool shady streets of the Wolflin Historic District are a popular place for charitable walks. The appearance of this street today is dramatically different than the same view in the 1920s. (Courtesy of the Amarillo Chamber of Commerce.)

Three

ARCHITECTURAL DESIGN

When the Wolflin Historic District was being considered for national historic status, a major factor in the process was the architectural styles of the buildings in the survey area. Early-20th-century suburban neighborhoods had certain characteristics and social concerns that contributed to their development. One example that applies to the Wolflin area is how the automobile affected architectural trends in the early 20th century, as well as the layout of neighborhoods. Early on, garages were detached structures deemed to be utilitarian buildings; however, by the 1930s, architectural planners began to incorporate them into home designs with architectural features that attached them to the house. This trend is evident in Wolflin Place and in Wolflin Estates. The earliest homes in both additions had detached garages.

Building materials and construction techniques of the time also influenced the architecture of the district. Builders were restricted to brick or stucco construction, with a minimum $5,000 building requirement to assure that homes were of a character in keeping with the plans of the developers for an upscale residential park for the substantial families of the city.

Predominant early architectural styles in the Wolflin additions were bungalows in the northern two-thirds of the district and an assortment of revival "High-Style" houses most prominent in the southern part of the district. A group of more modern dwellings that include contemporary features or that are without stylistic references are located throughout the district. Many post–World War II homes have features found in current suburban tract houses, with low profiles and spread-out brick veneers. The mixture of design in the district is generally an array of compatibility rather than a presentation of visual conflict. Many of the homes in the southern portion of the district are custom-designed mansions that incorporate traditional styles such as Tudor Revival, Colonial Revival, Classical Revival, and various Spanish-style homes with slate- and clay-tile roofs. The architectural diversity of Wolflin Estates is remarkable, and coupled with the sheer number of magnificent homes, it sets the stage for an unparalleled residential area.

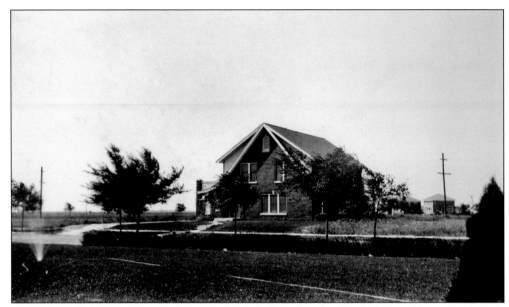

Tudor Revival characteristics such as steeply pitched roofs and multiple front gables were uniquely applied on this home at 1021 West Thirty-third Avenue, built in 1926. The first inhabitant, G. C. Fairey, a grain dealer, and the second owner, Albert Yake, a farmer, each lived in the house for a short time. J. J. and Nannie I. Currie made the dwelling their home from 1931 until the 1940s. (Courtesy of Pattilou Dawkins.)

Louis H. Smith and his wife, Elsie V. Smith, were the first owners of the Tudor-style residence at 3004 Hayden Street. The house, built in 1928, appeared in early publications touting the luxury of living in Wolflin Estates. Today the home has been remodeled extensively and bears little resemblance to the original appearance. (Courtesy of Pattilou Dawkins.)

Civic volunteer Jayne Brainard owns the turquoise Spanish Revival–style home at 2119 Lipscomb Street. The house was built by P. L. Reppert in 1929 for Hattie Miller at a cost of $7,000. Later John E. Cunningham, general manager of Southwestern Public Service, and his wife, Elynor, owned the home. Jayne and her late husband, E. S. Brainard, bought the home in 1961 from Clyde and Lillie Rehmeyer. (Photograph by Christine Wyly.)

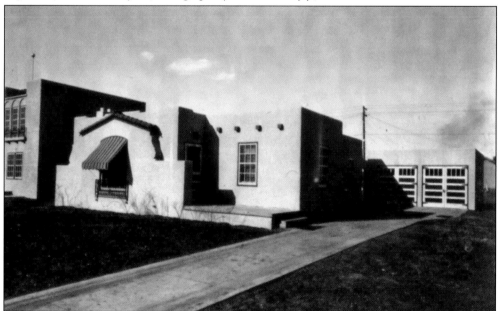

This early image of 2117 Lipscomb Street shows Spanish Revival–style features similar to the Brainard home next door; however, the one-story home, built in 1929, has elements of Pueblo Revival style, such as a flat roof and projecting, round roof beams known as vigas. Lawrence Garcia, who bought the home in the 1960s from heirs of the original owner, Mary Zelley, has kept the original design intact. (Courtesy of Betty Howell.)

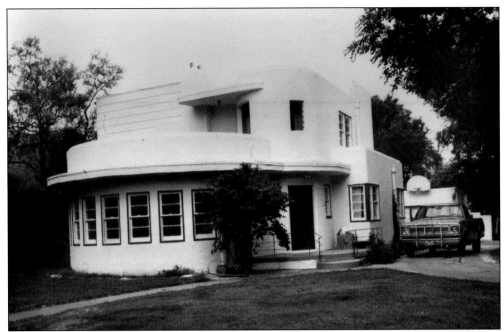

This mid-20th-century view of 2200 Ong Street is a picture of an architectural rarity in the Wolflin area and in Amarillo. A notable feature of the 1936 home is the stucco finish, which is not a usual exterior for area homes. The only other classic art deco–style home in Wolflin Place, located at 2618 Hayden Street, has a brick exterior. (Courtesy of the Amarillo Public Library.)

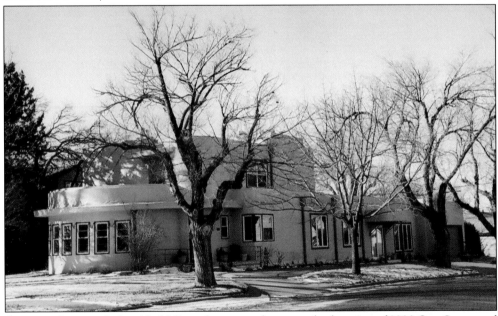

A winter photograph devoid of foliage showcases the corner lot location of 2200 Ong Street and reveals the art deco features. The house has been home to a cattleman, a baker, an attorney, and schoolteachers. It is now owned by Dr. Suzanne Helfinstine, who is maintaining the home in the art deco style and has decorated it with art deco furniture and artwork. (Photograph by Christine Wyly.)

42

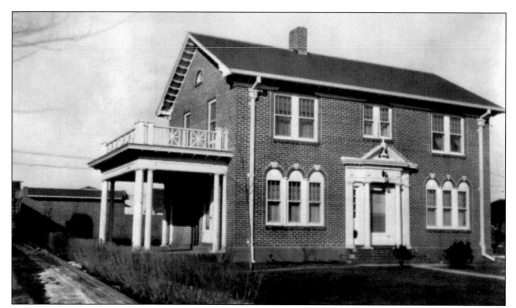

Prominent contractor C. S. Lambie built 2213 Hughes Street as his personal residence in 1927. The symmetrical Colonial Revival–style home also displays mission-style arched windows on the ground level. Adherence to rigid stylistic identification was not as common as providing known conveniences of the day to Wolflin home buyers. Lambie's firm built residences and high-profile buildings, including the Potter County Courthouse and the Kress Building. (Courtesy of Betty Howell.)

The first resident of 2215 Hughes Street in 1926 was John Cowan of Clowe and Cowan Wholesale Plumbing. His home was remarkable in that it was designed by the well-known architect Guy Carlander. The decorative half-timbering and the elaborate chimney exemplify classic Tudor design. (Courtesy of Betty Howell.)

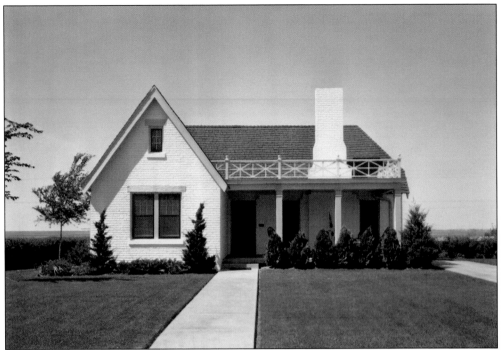

The 1931 construction of 2406 Lipscomb Street was advertised in the *Wolflin Neighborhood News* with the announcement, "Another insulated home!" Frank Jesse built the Tudor Revival–style home in cooperation with the Amarillo Lumber Company. Original construction included an arched brick entryway, which was torn out to make way for a columned front porch and decorative roof railing shown in this 1932 photograph. (Courtesy of Dr. Jack and Sandra Waller.)

A November 1940 winter storm left the illusion of icing on the pitched rooflines, railings, and ornate fencing at 2406 Lipscomb Street. Ten-year growth on the Siberian elm trees created a palette for the shimmering ice accumulation that happens often in the Texas Panhandle. (Courtesy of the Lawrence Hagy estate.)

Lawrence Hagy bought the Tudor Revival spec home at 2406 Lipscomb Street new in 1931 and remodeled the front entrance and porch. Stanley Marsh 3 owned the house from the mid- to late 1960s and further modified its original design by putting in a flat-roof addition. Dr. Jack Waller and his wife, Sandra, bought the home in 1975, remodeled the house in 1978, and removed the Marsh addition. The 1983 drawing above, by Amy Gormley Winton, depicts the appearance of the house from 1978 to 1993. The pen-and-ink drawing below, done by Leisa Durrett in the late 1990s, is a more modern look at the house. The bay window, cupola, and conservatory were added in 1993. (Courtesy of Dr. Jack and Sandra Waller.)

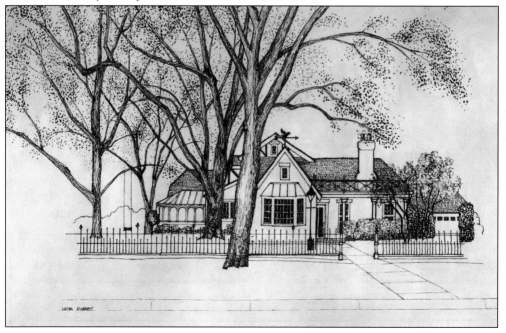

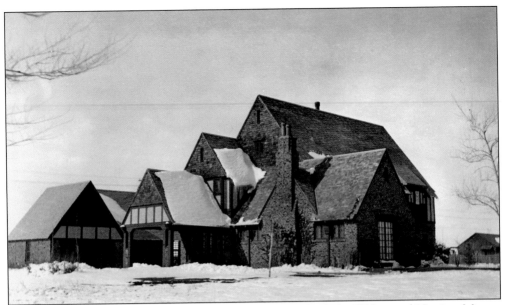

The enormous 1928 dwelling at 2806 Hughes Street was built for Walter and Harriett Mount. Walter, a traveling salesman, paid $28,000 for contractor George Parr to build the home. The house, constructed with classic Tudor Revival–style elements, included an elaborate, prominent chimney with chimney pots, half-timbering, and steep gable roofs. Other Tudor features are shed dormers that cut into the roofline and window muntins laid in diamond grid patterns. (Courtesy of Pattilou Dawkins.)

Elements of Tudor style are present in the home at 2413 Hayden Street, built in 1928. Salesman Frank W. Calvert was the first resident; however, by 1930, it was the home of Dr. August J. Streit, who lived in the house for many years. (Courtesy of Betty Howell, Rittenberry family collection.)

The Spanish Revival–style home at 2608 Hughes Street was included in the Texas Historical Commission survey during the national registry application process. The home was designed by C. W. Brott and was built by the Reppert Lumber Company in 1928 at a cost of $25,000. The home was furnished by Fakes-Palmer Furniture Company and was opened to the public as a model home. Two early views of the interior showcase furniture and wall treatments of the period as well as Spanish features, such as balustrades, arched alcoves, and arched doorways. Early resident George L. Kestler, a contractor, occupied the home for several years until 1933, when Bynum L. and Bessie Morgan bought the home. (Both courtesy of Betty Howell, Reppert-Beebe collection.)

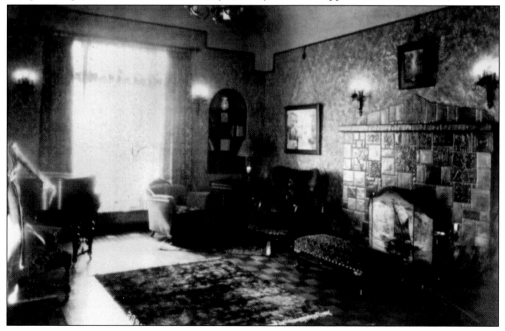

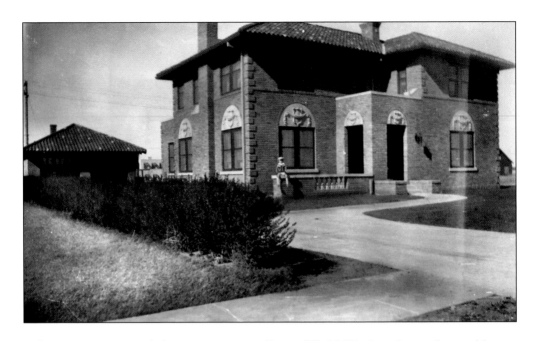

Italian Renaissance–style homes were generally pre–World War I, architect-designed homes located in larger cities during the 1920s and 1930s. The house at 2614 Hughes Street was custom designed by prominent architect Guy Carlander, who designed buildings such as the Northwest Texas Hospital, Amarillo College, the White and Kirk Building, and the Fisk Building. Carlander's characteristic design can be seen in the cast-stone reliefs over the first-floor windows. Classic Italian Renaissance elements are apparent in the symmetrical plan, the projecting wing, and the low-pitched, tile, hipped roof with a broad overhang. Attorney Ray C. Johnson Sr. hired McCasland Construction to build the home in 1927. The Johnson family still owns the home today, which is a rarity in the Wolflin Historic District. (Both courtesy of Ray C. "Charles" Johnson III.)

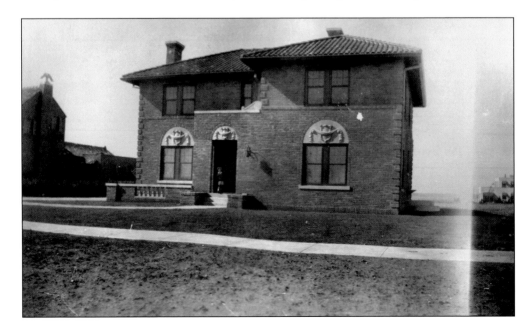

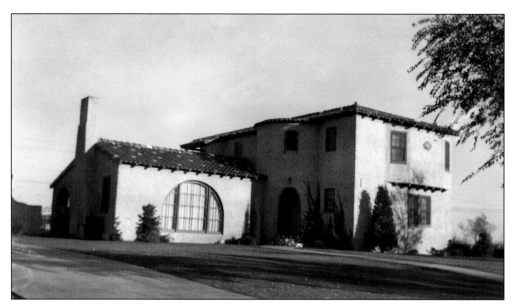

The house at 2815 Hughes Street is an example of the eclectic style known as Spanish Revival. Some features of the 1938 home by C. W. Brott are typical to the style, such as the round tower and textured stucco walls. Oilman Louis W. Timms first owned the house, but by 1943, oilman and cattleman Odice V. Beck resided there. Members of the Beck family own the house today. (Courtesy of Barry Beck Jones.)

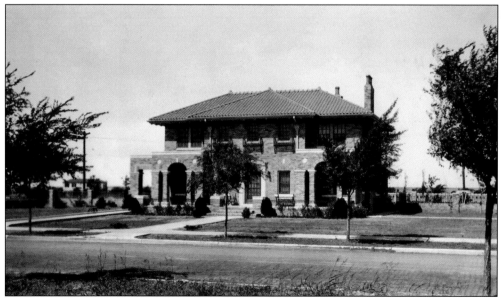

In 2004, the Texas Historical Commission placed an official state marker in front of the dwelling at 3002 Ong Street. The Recorded Texas Historic Landmark (RTHL) designation is the highest honor the state can bestow on a historic structure. The home, built in 1929, is predominantly in the Italian Renaissance style with some elements of the Mediterranean Revival style. (Courtesy of Pattilou Dawkins.)

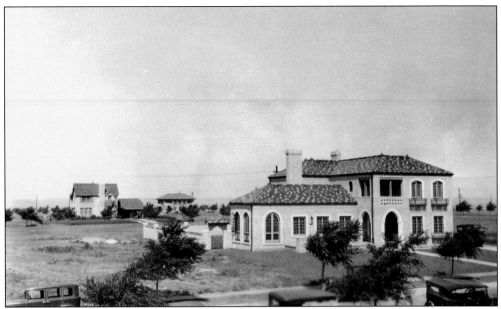

The Spanish Revival–style home built for grocer Crone W. Furr at 3006 South Hughes Street was designed by architect J. Roy Smith. Furr, the founder of Furr Food Stores, lived in the home described by the *Amarillo Daily News* on March 16, 1930, as "one of the finest in the entire Panhandle" until the 1940s. The home's construction cost of $40,000 was one of the more expensive of the time. (Courtesy of Pattilou Dawkins.)

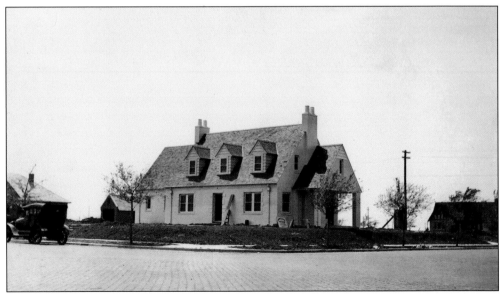

The Boyce home at 3200 Hayden Street is seen in this 1932 photograph shortly before its completion by builder Frank W. Jesse, with construction signs and contractors' materials still on the property. The Colonial Revival–style residence of attorney W. Q. Boyce and his wife, Ida, featured a symmetrical facade and gabled dormers. (Courtesy of Pattilou Dawkins.)

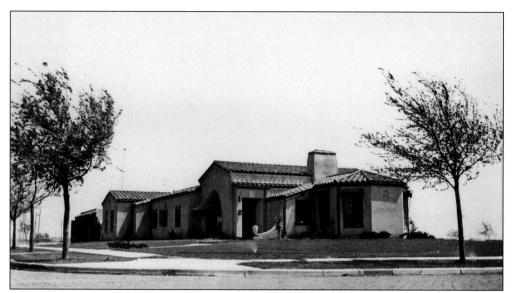

The house at 3201 Hughes Street, built in 1931 in the Spanish Revival style, has undergone additions throughout the years but retains its historical integrity. The unique home was built with a rambling one-story plan rather than the two-story vertical configuration of other Spanish Revival–style homes in the area. The home was built for Walter D. Caldwell, president and general manager of the Gibson Oil Company. (Courtesy of Pattilou Dawkins.)

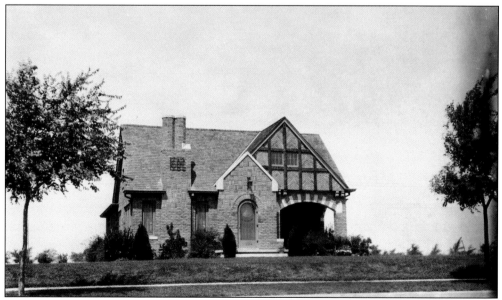

The early Wolflin Estate home at 3204 Hayden Street was constructed in 1927 for broker L. I. Davis by the Reppert Lumber Company. The Tudor Revival style is apparent in the ornate chimney and half-timbering. Today this home's original charm is amplified with a tasteful addition on the south side, an iron fence, and extensive landscaping. (Courtesy of Pattilou Dawkins.)

As the Wolflin subdivisions moved westward after World War II, designs other than the "High Style" homes from earlier eras became more prevalent. Many ranch-style homes were built in Wolflin Park, developed by Charles A. Wolflin, during that period; however, the 1949 home at 2203 Travis Street, currently owned by Keith and Parie Villyard, is an example of other modern styles present in the area. (Photograph by Christine Wyly.)

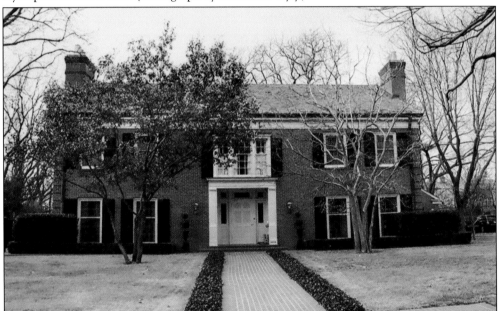

The house at 3006 Ong Street is a regal, elegant home built by Shelby Masterson Kritser and his wife, Jeanne Howe Kritser. She found a home in Dallas that looked similar and contracted Dallas architect Charles Witchell, who designed the house with Georgian features, including paired chimneys and a decorative cornice. The house, constructed by Frank Jesse, has been home to members of the Kritser family since 1956. (Photograph by Christine Wyly.)

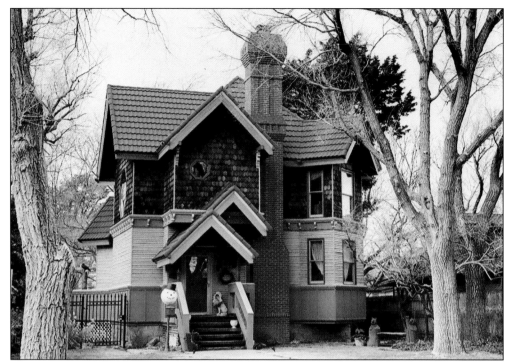

This 1983 Victorian home, though built in a more modern era, replicates the Victorian Stick style common in the United States in the mid- to late 1800s. It is unique to the Wolflin Historic District, but its brightly painted exterior adds to the character of the neighborhood. (Photograph by Christine Wyly.)

Original deed restrictions for Wolflin Place mandated that servants' quarters be located at the rear of homesites. This picture shows the required rear-entrance door in the alley that led into a garage apartment built as servants' quarters in the 1920s. Most servants' quarters have been converted into storage or recreational buildings in modern times. (Photography by Christine Wyly.)

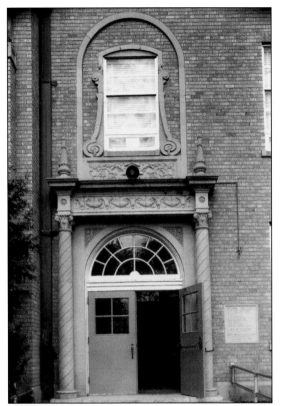

Wolflin Elementary School was named after Charles Oldham Wolflin and was constructed in 1926. The architect, Emmett F. Rittenberry, designed many buildings in Amarillo and lived in the Wolflin Historic District. Rittenberry partnered with Macon Carder, another Amarillo architect who lived in Wolflin Place for many years, to design the Mission Revival–style Wolflin Elementary School. The architects added Italian Renaissance ornamentation to the light brick building with a low-pitched tile roof. The building is adorned with a beautiful brickwork frieze near the roofline and cast-stone volutes and spandrels panels at the front entrance. The school was remodeled by Rittenberry and Associates in 1982, with James "Jimmy" Rittenberry, grandson of the original architect, working on the project. (Both courtesy of the Amarillo Public Library.)

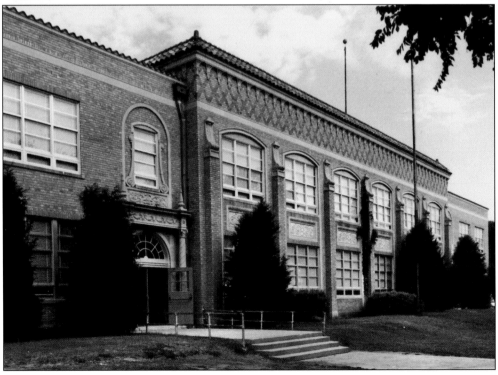

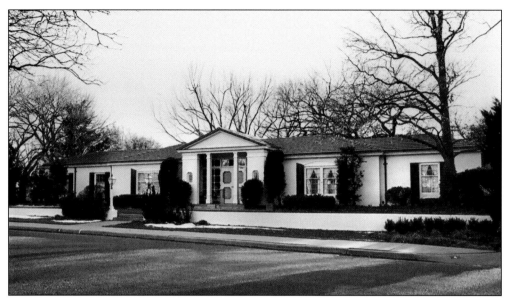

Tol and Mary Ware own this neoclassical-style home with Greek influences on Greenwood Lane in Wolflin Park. Wolflin Park, developed by Charles A. Wolflin, is adjacent to Wolflin Estates. The distinctive style of the Wares' home stands out in the neighborhood and has withstood the test of time as an example of classical design. (Photograph by Christine Wyly.)

Clyde Crump lived at 33 Oldham Circle in the 1950s and 1960s in what some people called "the ugliest house in Wolflin." This undated photograph depicts the appearance of the home during that time. The home has undergone extensive renovations since that time and would not be recognizable today to someone who knew it 50 years ago. (Courtesy of Pattilou Dawkins.)

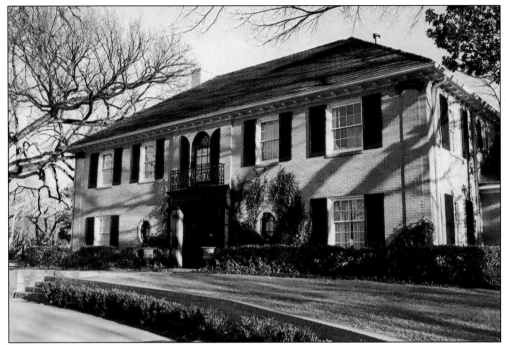

The Oldham Circle home of Benjamin T. Ware III has a dignified presence among the Siberian elm trees of the district. Benjamin T. Ware III is the great-great-grandson of the founder of Amarillo National Bank, the largest family-owned bank in the United States. (Photograph by Christine Wyly.)

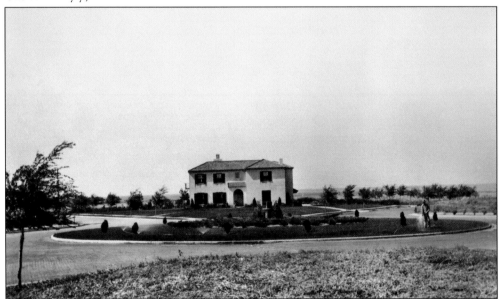

The stunning Spanish Revival–style home at 35 Oldham Circle was built in 1927 for Frank and Orlena T. Wolflin. This picture, taken within a year or two of construction, shows a panoramic view of the western prairie beyond. The historic home is a well-known landmark that stood alone on Oldham Circle for many years after the Great Depression curtailed further development. (Courtesy of Pattilou Dawkins.)

Four

GROWING UP IN WOLFLIN

People of various ages who grew up in the Wolflin Historic District all say the same thing: "Wolflin was a wonderful place to grow up!" Most started school at Wolflin Elementary School, and many went on to Austin Middle School and Amarillo High School when they got older. Both the elementary school, located at the north end of the Wolflin Historic District, and the middle school are in the Wolflin subdivisions. The Wolflin Elementary School, in particular, was, and still is to some extent, the thread that binds the fabric of the district together.

Friendships started in the 1920s and 1930s still exist today, and there is almost a sense of kinship among many residents who grew up together. In many cases, the friendships of parents generated friendships among their children, and whole families spent weekends and holidays together. The oldest residents of Wolflin talk about the days before homes were built west of Wolflin Place when they would ride horses for miles across the prairie. Some residents who grew up in the early to mid-1900s relay their experiences of going through back doors and gates to garage apartments or alleyways to play with the children of servants who worked in the front houses.

Children of every era climbed the Siberian elm trees throughout the historic district and rode bicycles for miles, visiting and playing for hours. Childhood stories of faithful dogs as playmates, impromptu parades, softball games in the field down by Thirty-fourth Avenue, and street football games are common. The more mischievous residents tell of BB-gun fights, rock fights, and, as teenagers, setting bonfires and racing their cars through the streets. Most agree their years growing up in Wolflin were delightful and full of fun and camaraderie, which helped form the basis of their social activities and interests for adulthood.

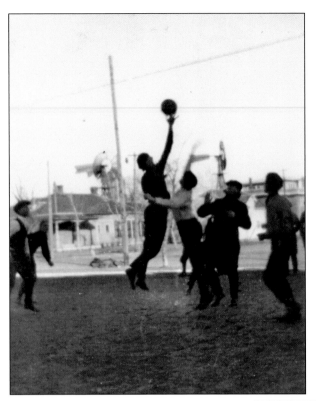

Basketball was a popular pastime in the Wolflin neighborhoods in the 1920s. In this picture, teenage boys play basketball in a lot near Wolflin Elementary School. Windmills were still widely used in the 1920s and can be seen next to the houses in the background. (Courtesy Pattilou Dawkins.)

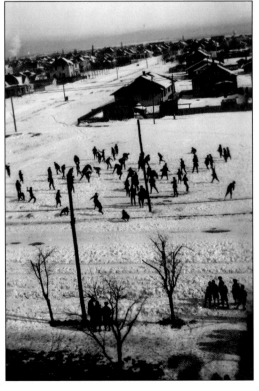

This 1920s image of young people sliding and skating is an example of the camaraderie that existed throughout the Wolflin area among the young people of the time. During the Depression, teenagers improvised and turned empty lots into skating rinks in icy weather. (Courtesy of Pattilou Dawkins.)

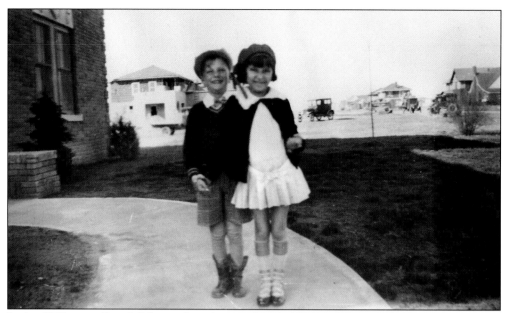

In this 1927 image, Ray C. Johnson Jr. and an unidentified little girl appear to be dressed for a special occasion. The children, who were early residents of Wolflin Historic District, socialized with rules of etiquette similar to those observed by the adults. Birthday parties were often formal affairs with proper invitations and newspaper coverage. (Courtesy of Ray C. "Charles" Johnson III.)

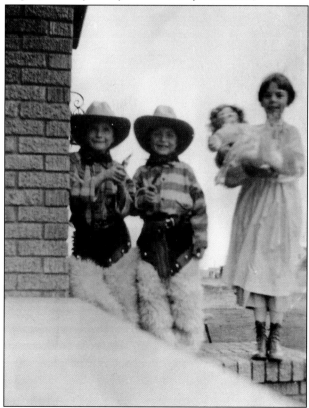

Standing in front of 2614 Hughes Street in 1927 are, from left to right, Ray C. Johnson Jr., Roy Vineyard, and an unidentified girl. The boys, dressed in Western costumes, seem to be proud of their wooly chaps. Roy Vineyard, now in his 80s, fondly remembers wearing the wooly chaps. (Courtesy of Ray C. "Charles" Johnson III.)

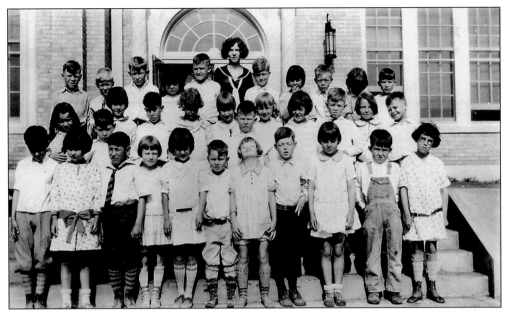

Woodrow Baldwin was in the original first-grade class at Wolflin Elementary School. He is pictured here in 1927 in the first row, eighth from left, with his second-grade classmates. Baldwin later attended Amarillo High School, Amarillo College, and the University of Oklahoma and received his doctorate at the University of California, Los Angeles. Baldwin is retired from a distinguished career in academia. (Courtesy of Woodrow Baldwin.)

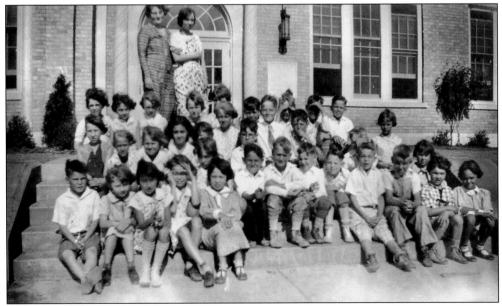

This second-grade class poses on the front steps of Wolflin Elementary School in 1929 with principal Ethel Jackson (left), who taught sixth grade, and Mary Meador, who taught second grade, standing behind the students. As seen by the girls' hair, it was a typical windy spring day in the Texas Panhandle. (Courtesy of Ray C. "Charles" Johnson III.)

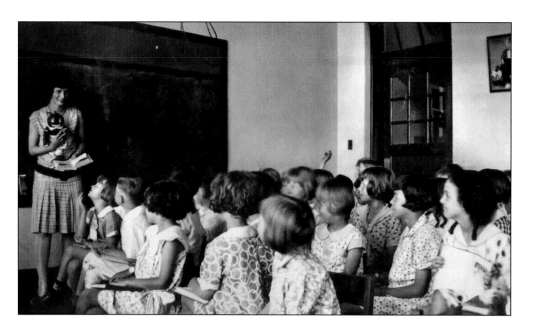

The 1928–1929 Wolflin Elementary School first-grade class was taught by Grace Fain. Above, on the last day of school in May 1929, Fain is pictured standing in front of her classroom with her students' undivided attention. Below, in another view, the children concentrate on their studies as Fain oversees their efforts. Of note is the appearance of the 1920s-era classroom and the furnishings. The open transom over the classroom door facilitated ventilation in the classroom in the days before air-conditioning became available. When the school opened in 1926, it was one of the most modern in the state, with the newest scientific methods of lighting, heating, and ventilation. (Both courtesy of Ray C. "Charles" Johnson III.)

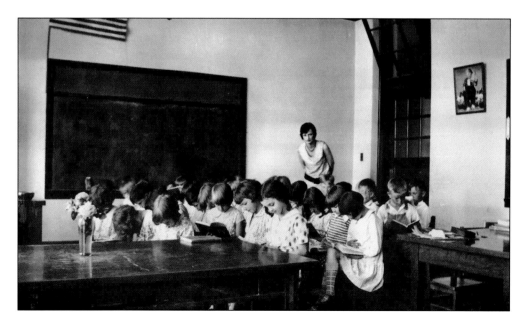

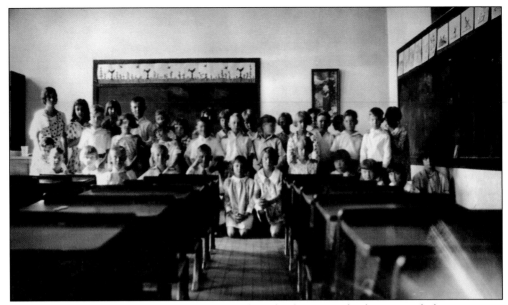

This 1929 Wolflin Elementary School second-grade classroom displays typical characteristics of the era. Of note are the wooden school desks, old-fashioned blackboards, and wooden floor. The quotation in Ray C. Johnson Jr.'s photo album above this picture was "our dear little room." (Courtesy of Ray C. "Charles" Johnson III.)

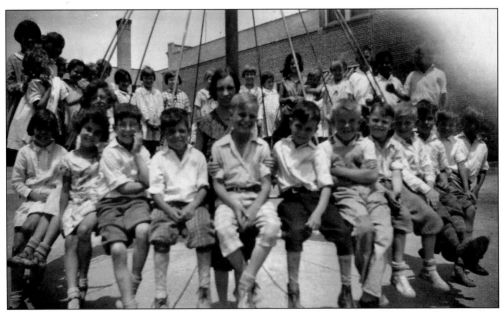

In this 1929 picture, students at Wolflin Elementary School pose on and around their favorite amusement, the "Ocean Wave." The seating, hung from cables mounted on a pole, was set in motion by the children in a sideways movement that mimicked ocean waves. The giant swing was removed in later years because it was deemed to be too dangerous. (Courtesy of Ray C. "Charles" Johnson III.)

Mary Meador was the second-grade teacher at Wolflin Elementary School in 1929. In this photograph, Meador (left) is standing by the monkey bars in the school playground with Ray C. Johnson Jr., who grew up on Hughes Street. (Courtesy of Ray C. "Charles" Johnson III.)

Grace Fain (left) moved to Amarillo to teach school and lived with her sister Marian Dyer on Fountain Terrace in the Country Club addition. Fain began teaching at Wolflin Elementary School at mid-term in 1926. She taught there until she married Charles A. Wolflin in 1930. Fain is pictured here on the playground in 1929 with Ray C. Johnson Jr. (Courtesy of Ray C. "Charles" Johnson III.)

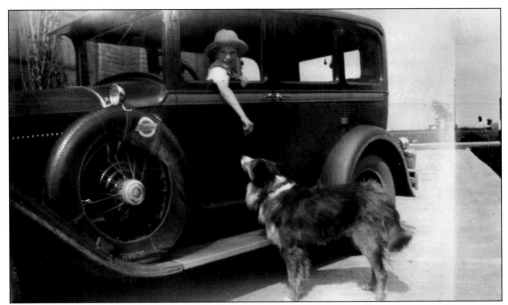

Ray C. Johnson Jr. grew up at 2614 Hughes Street. This 1928 picture of him posing in the window of the family car with his dog, Lindy, standing by, shows a background of empty lots around the home. It was well into the 1940s before the surrounding lots were developed. (Courtesy of Ray C. "Charles" Johnson III.)

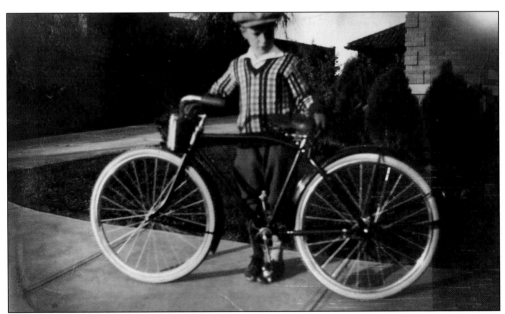

Bicycles were an integral part of growing up in the Wolflin Historic District. Ray C. Johnson Jr. is pictured here with his first bicycle in 1929. He rode often with Roy L. Vineyard Jr. and Walter Mount Jr. (Courtesy of Ray C. "Charles" Johnson III.)

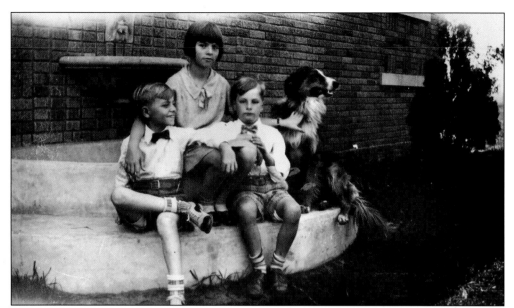

Roy Vineyard and Ray C. Johnson Jr. played together from early childhood and remained lifelong friends. Johnson's dog, Lindy, named after Charles Lindburgh, was their constant companion. Vineyard remembers the day Lindy died; Johnson rode his bicycle to his house, and both boys cried and cried. Similar stories of lifelong friendships are common among people who grew up in the Wolflin Historic District. Johnson became an avid photographer and world traveler as an adult. Vineyard, in his late 80s, is in the insurance business and still goes to the office each day. Pictured above and at right, from left to right, are Roy Vineyard, Doris Vineyard Hodde, Ray C. Johnson Jr., and Lindy. (Both courtesy of Ray C. "Charles" Johnson III.)

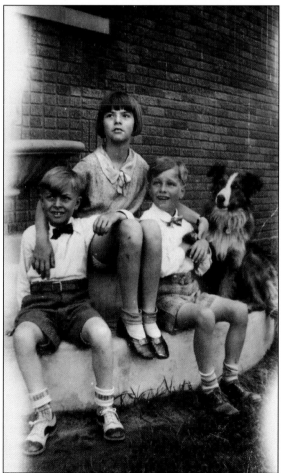

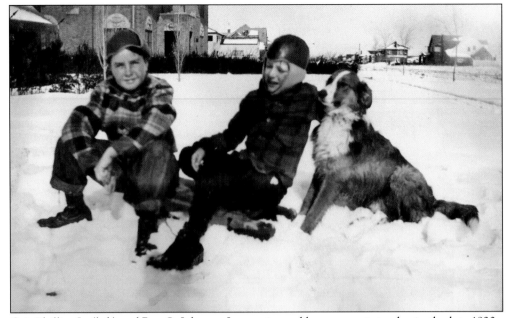

Otis Phillips Jr. (left) and Ray C. Johnson Jr. are pictured here on a winter day in the late 1920s. The boys, dressed for snow sledding, are sitting at the corner in front of 2618 Hughes Street. (Courtesy of Ray C. "Charles" Johnson III.)

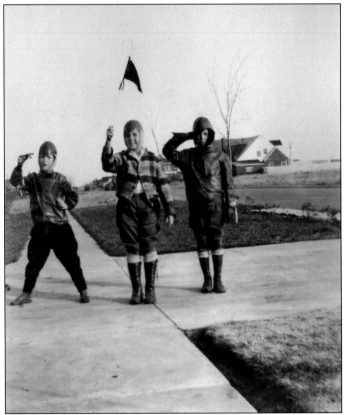

The three boys shown here playing on Hughes Street are indicative of countless stories of children who grew up in the Wolflin Historic District. Children stayed outside in all seasons, developed friendships, formed teams, and played for hours. (Courtesy of Ray C. "Charles" Johnson III.)

This photograph was taken on Armistice Day, November 11, 1928, just 10 years after hostilities ceased on the Western Front between the World War I Allies and Germany. After World War I, the United States celebrated the day as a national holiday, as depicted by Ray C. Johnson Jr. holding the American flag. Today November 11 is celebrated as Veterans Day. (Courtesy of Ray C. "Charles" Johnson III.)

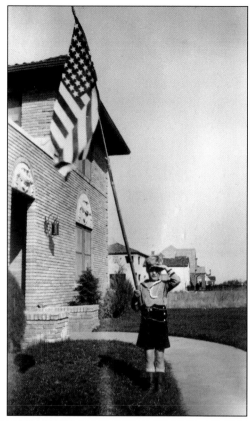

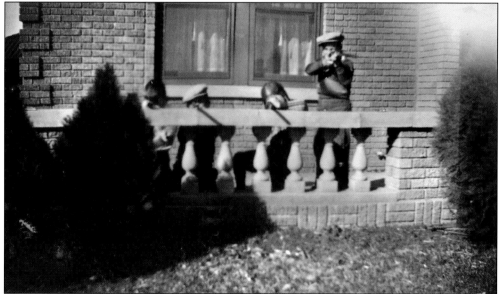

This 1920s image shows boys armed with BB guns using the balustrade at 2614 Hughes Street as a fort. Walter Mount Jr., Otis Phillips Jr., and Ray C. Johnson Jr. played together on Hughes Street often. Other frequent playmates included Merrill Winsett, Richmond Underwood, and Roy L. Vineyard Jr. (Courtesy of Ray C. "Charles" Johnson III.)

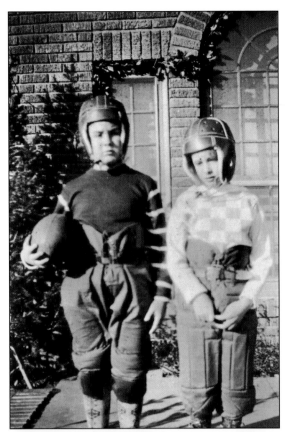

Residents of Wolflin Place and Wolflin Estates were generally affluent and could afford the best clothing and other luxuries. Sports equipment was no exception. These late-1920s pictures of Ray C. Johnson Jr. (right) and an unidentified friend show the boys dressed in football gear. The gear, including helmets, pads, and footballs, became more difficult to obtain in the early 1930s when the Great Depression started; however, stories of forming teams and playing football games in empty lots are told by residents who lived in the Wolflin additions during the Depression and World War II. Those stories are indications that hard times, war, and lack of equipment were not enough to stop the camaraderie among the children who grew up there. (Both courtesy of Ray C. "Charles" Johnson III.)

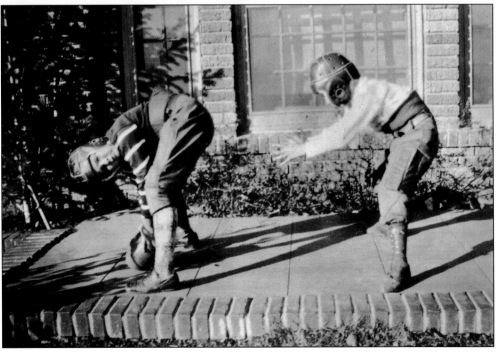

This mid-1930s picture of Nita Johnson Griffin was taken on the porch of her parents' home at 2122 Hughes Street. Griffin was three when her family moved into the home and remembers, as does her sister Elaine Johnson Edwards, that they had "incredible fun" growing up there. (Courtesy of Nita Johnson Griffin.)

Jayne Brainard remembers her maternal grandparents, Joe L. and Marie Williams, living on Hayden Street when she was growing up. They are pictured here in front of their home with Brainard's daughter Sydney Brainard in 1954. (Courtesy of Jayne and Sydney Brainard.)

In this photograph taken in the backyard of 2815 Hughes Street, Barry Beck Jones was about three years old. Born in 1945, Jones, who grew up at the house, remembers the vacant lot across the street being a perfect place to dig foxholes and play games for hours. (Courtesy of Barry Beck Jones.)

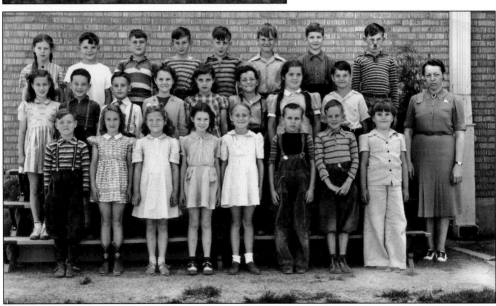

Maxine Sloneker, a Wolflin resident, was the teacher of this 1941–1942 class at Wolflin Elementary School. Marshall Hunter Puckett, Charles O. Wolflin's grandson, is in the second row, fifth from left. He built the popular drive-through restaurant, Char-Kel, near the Wolflin area in 1968. (Courtesy of Pattilou Dawkins.)

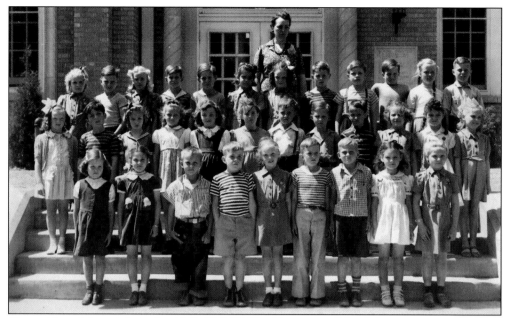

Pictured from left to right in this 1942–1943 Wolflin Elementary School class picture are (first row) Barbara Hibbs, Beth Sanders, Kenneth Welch, Lawrence Griffith, Shirley Nelson, Robert Crawford, Gary Thornton, unidentified, and Althea Jacobson; (second row) Sue Anna Skaggs, Marty Fenberg, Barbara Morris, Ann Pittman, Elaine Steele, Pattilou Puckett, Pat Stambough, Earl Dean ?, Bobby Hailey, Sue Lewis, Mary Ann Dysart, and Nancy Adams; (third row) Theodocia Zweig, Wayne Godsey, Donna Lemons, Jackie Miller, Mickey Vineyard, Joyce Foreman, Barbara Wood, Don Stensass, Roger Fryer, Walter Johnson, Sue Smiley, and Carl Johnson; (fourth row) teacher Maxine Sloneker. Absent that day were Don Dwight and Earl Crouch. (Courtesy of Pattilou Dawkins.)

Oilman A. C. "Bub" Smith, son of O. Dale and Clara Currie Smith, grew up on Hayden Street. He is pictured here with his sister Claire Smith and their dog, Butch, in their living room on Hayden Street in the 1940s. He still lives in the district today on Ong Street in a home once owned by Mayor J. Ernest Stroud. (Courtesy of A. C. "Bub" Smith.)

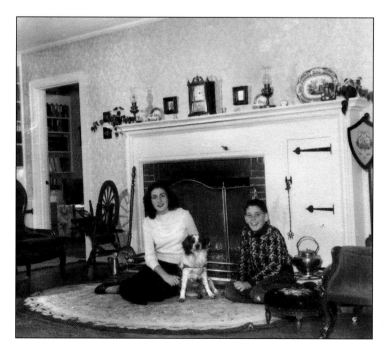

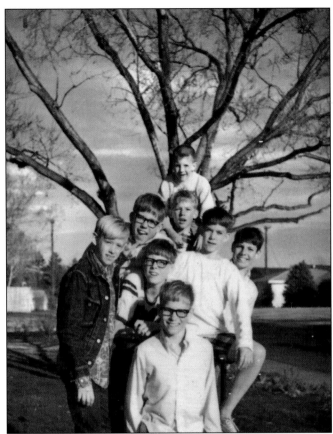

This 1968 photograph of Wolflin neighborhood boys was taken close to the intersection of Bowie Street and West Thirty-second Street. From left right are (first row) Bill Attebury; (second row) Berkley Dawson, Craig Tollison, and Shon Barnett; (third row) Wynne Monning, Ray C. "Charles" Johnson III, and Robert Garner; (fourth row) Shelby Puckett. (Courtesy Ray C. "Charles" Johnson III.)

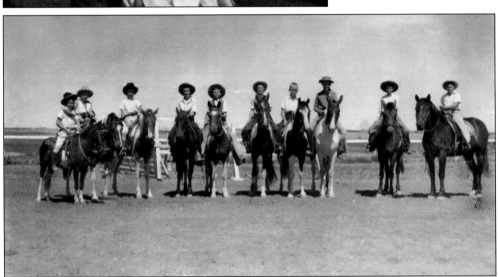

Wolflin Stables, at Wolflin Avenue and Travis Street, was close to the Wolflin Park Golf Links. Residents were admonished in a 1932 *Wolflin Neighborhood News* to refrain from riding across the golf course. A group of boys riding in 1931 are, from left to right, Buddy Myer, Dick Cline, Billy Kistler, Eugene McCartt Jr., G. C. Claybrook, Bittie Callahan, William Klinginsmith, Joe Tom Glover, and two unidentified. (Courtesy of Joseph R. "Joe Bob" McCartt.)

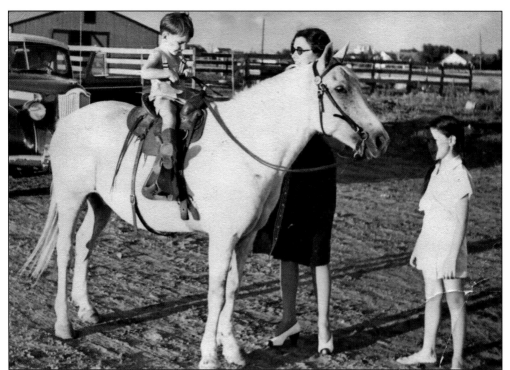

A. C. "Bub" Smith is pictured here at the Wolflin Stables in the early 1930s on a new pony he shared with his sister Claire. The Jimmie Hamilton Riding Academy opened at the stables on April 3, 1932. The stables housed the academy and boarded residents' horses until it burned down in the late 1930s, killing several horses. (Courtesy of A. C. "Bub" Smith.)

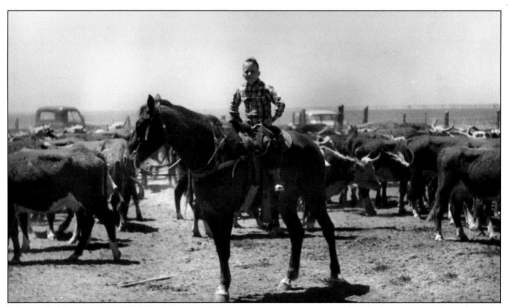

Many children in the Wolflin Historic District spent time on ranches belonging to their friends' parents. This 1954 picture of Joe Bob McCartt on horseback was taken at the Currie Ranch. Today McCartt is a commercial real estate broker. (Courtesy of Joseph R. "Joe Bob" McCartt.)

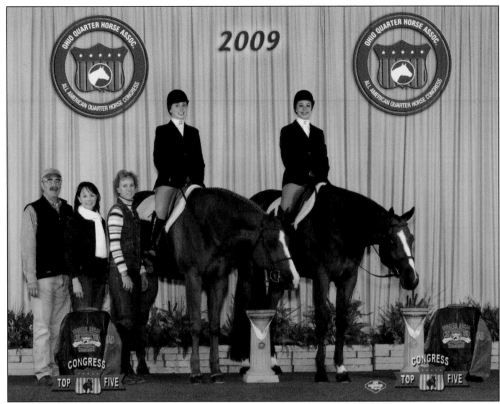

Today some children of Wolflin ranching families still enjoy riding horseback at the ranch and competing in other equestrian activities. The young ladies mounted on registered American Quarter horses are Peyton (left) and Jenny Bivins. They live with their parents, Thomas P. and Julie Bivins, in the home rancher Jay L. Taylor lived in for many years. (Courtesy Thomas P. and Julie Bivins.)

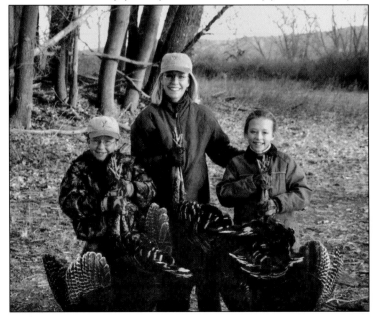

Ellen Smith Bivins is the granddaughter of oilman O. Dale Smith. The Smith family has lived in the Wolflin Historic District for many years. She and her husband, Mark E. Bivins, currently live in a 1950 home in Wolflin Estates. Pictured from left to right are Miles, Ellen Smith, and Emily Bivins after a 2005 turkey hunt on the XL Ranch. (Courtesy of Mark E. and Ellen Smith Bivins.)

Five

COMMUNITY
AND RESIDENTS

Pattilou Dawkins attests that the beauty of Wolflin was the sense of community and the fact that all her friends lived within a three-block radius of her house when she was growing up. From the very beginning, the development of the Wolflin Historic District was advertised in Amarillo city directories as a "pleasant location, surrounded by friendly neighbors" and "a place where people can live better and be happier." In some ways, the lifestyle those advertisements proclaimed became a reality for residents. There are various reasons for the sense of community residents enjoyed from the late 1920s until late in the 20th century. People who were first- and second-generation settlers in Amarillo were among the initial wave of new home buyers in the district. Those people, endowed with a pioneer mind-set, worked together to fulfill their vision for a premier residential community.

After the Depression, pipelines were developed to transport the Panhandle's oil and natural gas to markets where it could be sold. Consequently, those who had persevered began to see better economic conditions. The outlook was hopeful, and people who had worked together during the Depression just to stay alive began to cooperate again to build the community. Progress was halted again when World War II began; men left to go to war, and the women who stayed behind stood in to fill the gap in their families. Many, even affluent, ladies went to work or volunteered to help in the war effort.

From the 1920s, friendships were shaped, clubs were organized, and charitable and civic activities were the center of social activity. By sharing the experiences of difficult times, people formed bonds that have made the Wolflin Historic District a place where entrepreneurship, public service, generosity, and support of fine arts among the residents is the standard.

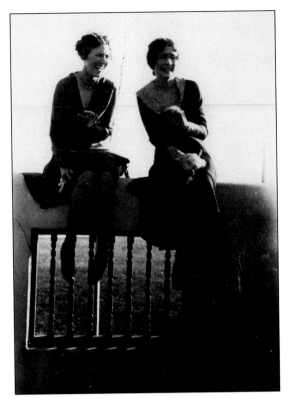

Clara Currie (right) and Lela Wolflin are pictured here in 1926. They were lifelong friends as close as sisters who traveled together to Europe and elsewhere. Their fathers, Thomas Currie and Charles O. Wolflin, were friends as well, and after Wolflin died, the families remained close. Their children and grandchildren were, and still are, friends today. (Courtesy of Pattilou Dawkins.)

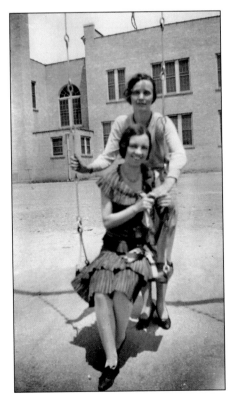

As early teachers at Wolflin Elementary School, Mary Meador and Grace Fain were important contributors to the success of the modern new school. In this 1929 photograph taken in the schoolyard, Fain stands behind Meador, who is seated on the swing. (Courtesy of Ray C. "Charles" Johnson III.)

Ethel Johnson (left) sits on the porch of her home at 2614 Hughes Street with her sister (name unknown). Johnson, in later years, told of putting a fence around her yard at the 1927 home to keep cowboys who were on their way downtown from riding their horses through her rose garden. At the time, Hughes Street was the last developed street in the Wolflin Historic District. (Courtesy of Ray C. "Charles" Johnson III.)

Attorney Ray C. Johnson Sr. is pictured here with his son Ray C. Johnson Jr. The elder Johnson witnessed Charles O. Wolflin's will, along with R. E. Underwood. He also worked with developers to draft the deed restrictions for the Wolflin subdivisions. Johnson was general counsel for Amarillo-based Shamrock Oil and Gas Company, which later became Diamond Shamrock Oil and Gas Company. (Courtesy of Ray C. "Charles" Johnson III.)

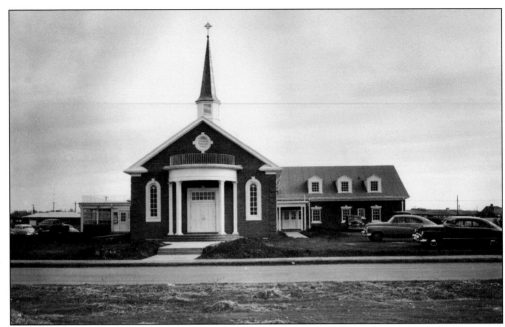

The Westminister Presbyterian Church stands at the edge of the historical district in Wolflin Park. Its stately architectural design facilitates a seamless integration with the homes in the Wolflin Historic District. The church was chartered in 1951 as the third Presbyterian church formed in Amarillo. The first session of elders was M. M. Laing, Charles Meadors, Lawrence Tucker, Guy Saunders, R. L. Gifford, Jake Wilhelm, and Dr. William E. Everheart, who was the founding pastor. The church has played host to many weddings, funerals, and services for the Wolflin community and other Amarillo residents. Above is a photograph of the original church soon after construction was completed in 1952. Below is a drawing by architects Emmett F. Rittenberry and James F. Rittenberry when the new addition was built in 1965. (Both courtesy of Westminister Presbyterian Church.)

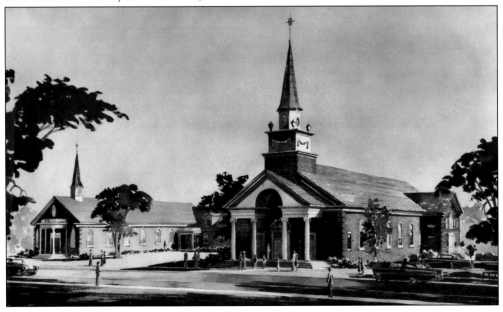

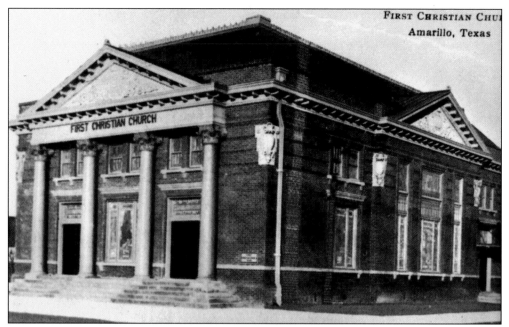

The First Christian Church was chartered in 1889 by 14 members, including Charles O. Wolflin, Frank Wolflin, and George H. and Lena M. Wolflin. This elegant, redbrick building was located at Eighth Avenue and Taylor Street in downtown Amarillo from 1909 until 1965. It is unknown why the Wolflins attended the First Christian Church because, in later years, many members of the family attended Presbyterian churches. (Courtesy of the Amarillo Public Library.)

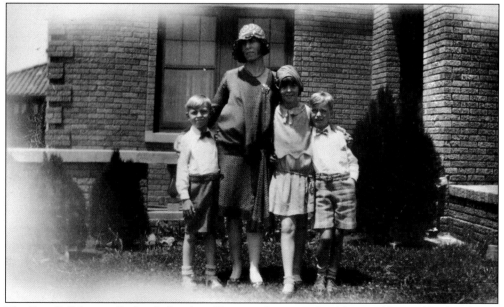

The Ray C. Johnson Sr. family lived on Harrison Street in the Oliver-Eakle neighborhood near the family of Dr. Roy L. Vineyard Sr. prior to moving to Wolflin Place. The families visited each other often after the Johnsons moved. Posing in front of 2614 Hughes Street are, from left to right, Roy L. Vineyard Jr., Vesta F. Vineyard, Doris Vineyard, and Roy C. Johnson Jr. (Courtesy of Ray C. "Charles" Johnson III.)

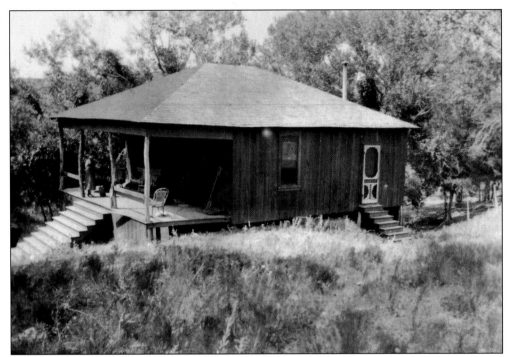

This cabin at the Palo Duro Club, 15 miles south of Amarillo, belonged to the Currie family, who were friends and neighbors of the Wolflins. Charles O. Wolflin built one of the first cabins in the private club in 1908. According to the *Wolflin Neighborhood News*, Charles A. and Grace Wolflin spent the summer at the Palo Duro Club prior to moving into the home at 2037 Hughes Street in September 1931. (Courtesy of Pattilou Dawkins.)

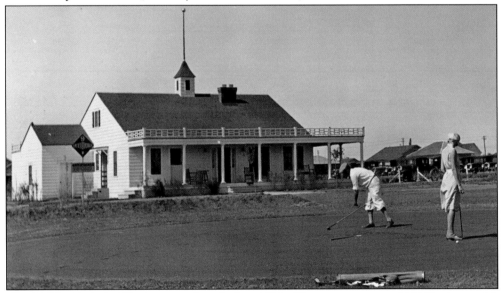

The Wolflin Park Golf Links opened in the late 1920s. The managers were P. F. Denson and J. E. Bush. The course offered golf lessons to residents and played host to tournaments for both young and old. In this picture, a golfer stands by while a worker smooths the sand-and-oil green. (Courtesy of Gretchen Wolflin Izett.)

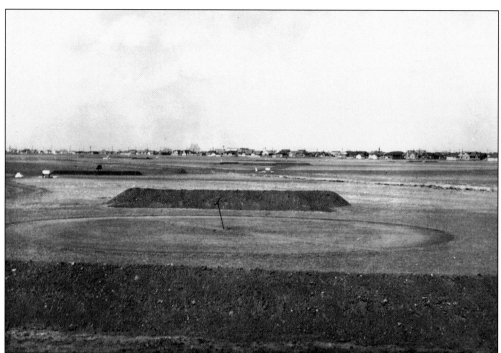

The photograph above shows a green on the Wolflin Park Golf Links dirt golf course with a stake marking the eighth hole. It is thought the greens were constructed with sand and oil because water was scarce and grass would not grow in the Texas Panhandle during the Depression. Sand was mixed with oil to keep the Panhandle winds from destroying the course. (Courtesy of Pattilou Dawkins.)

The *Wolflin Neighborhood News* was published for several years in the beginning of the Wolflin development. The publication listed homes for sale, relayed neighborhood gossip, and posted public service information. This September 1931 edition focused on new homes and street paving. (Courtesy of Dr. Jack and Sandra Waller.)

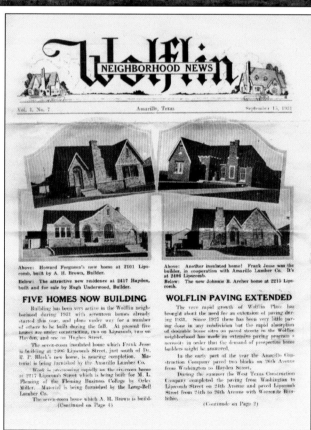

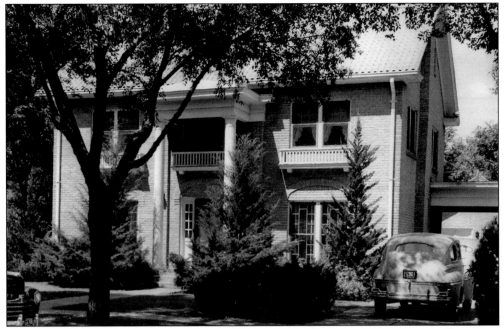

An early home in Wolflin Place was built in 1925 by Ford dealer W. C. Irvin at 2122 Hughes Street. In 1936, the Edward B. Johnson Jr. family moved into the dwelling. The adjacent "playhouse" was built in the mid-1940s and was a popular location for parties. Johnson, a cattleman, lived in the home until 1980, when he moved to Bryan Place. (Courtesy of Nita Johnson Griffin.)

This 1940 image of the Edward B. Johnson Jr. family shows them dressed for church on a Sunday morning. Pictured from left to right are Elaine Johnson, Edward B. Johnson Jr., Edward B. Johnson III, Juanita Willis Johnson, and Nita Johnson. (Courtesy of Nita Johnson Griffin.)

Edward B. "Eddie" and Juanita Johnson entertained often in their Wolflin home. This anniversary party took place in the playhouse adjacent to the home on Hayden Street. Attending the party, from left to right, are unidentified, Malcolm Shelton, Lela Wolflin Puckett, Margaret Johnson, Eddie Johnson, Sybil Harrington, Juanita Johnson, Minnis Hall, William O. Boyce, and Cedar Puckett. (Photograph by Ray Wagner; courtesy of Nita Johnson Griffin.)

In August 1947, the only private pool in the Wolflin Historic District was at the home of Edward B. Johnson Jr. This pool party was in conjunction with a bridal brunch in honor of Elaine Johnson, given by Clara Smith, who lived behind the Johnsons on Hayden Street. (Courtesy of Nita Johnson Griffin.)

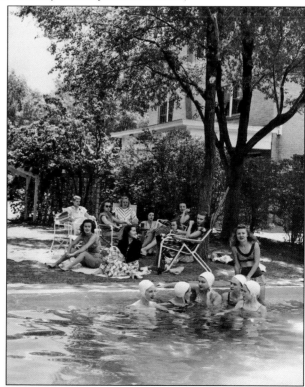

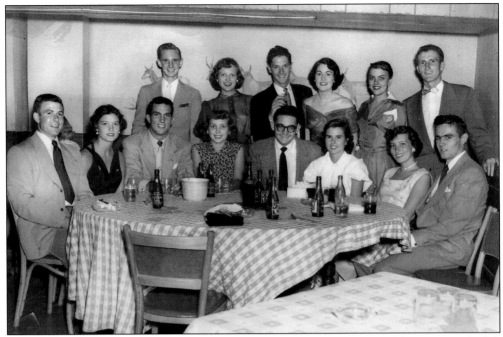

Nita Johnson organized this gathering of young Wolflin residents at the Old Tascosa nightclub in the basement of the Herring hotel in 1952 in honor of a college friend. From left to right are (first row) Bobby Hibbs, Gretchen Wolflin, Howard Childers, unidentified, Tabor Scott, Kathy Stofft, Nita Johnson, and Tommy Cleek; (second row) Guyon Lindsay, Melody Starks, John Southwood, Claire Smith, Shirley Feierabend Fancher, and Joe Saunders. (Courtesy of Nita Johnson Griffin.)

Edward B. "Eddie" and Juanita Johnson married in 1922 and subsequently moved to Amarillo. This 1970 Christmas night photograph was taken several years before Juanita Johnson died in 1973. Eddie continued to live in the family home on Hughes Street for seven years after she died, entertaining family members for Sunday lunch as he had before his wife died. He died in 1984. (Courtesy of Nita Johnson Griffin.)

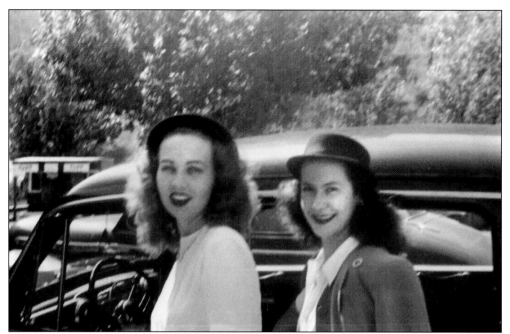

Early residents who formed friendships in the Wolflin Historic District often went on outings and took trips together. Helen McCartt (left) and Mary Ware are standing outside their car while on a trip with their husbands, Eugene McCartt Jr. and Tol Ware (seen below). The McCartts lived at 2211 Hayden Street until moving to an Oldham Circle home in 1952. (Courtesy of Joseph Robert "Joe Bob" McCartt.)

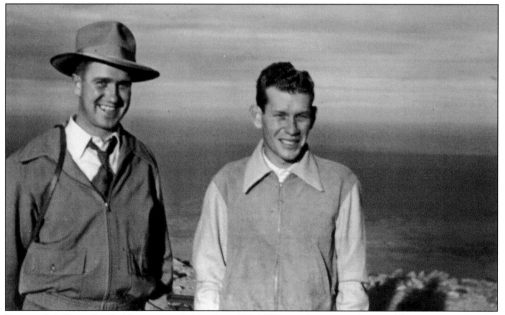

Eugene McCartt Jr. (left) poses with his friend Tol Ware, who was in his wedding party, at a stop during the trip with their wives above. McCartt was a grocer whose father, Eugene McCartt Sr., had come to Amarillo to work for Furr Food Stores and later owned McCartt's Grocery. (Courtesy of Joseph Robert "Joe Bob" McCartt.)

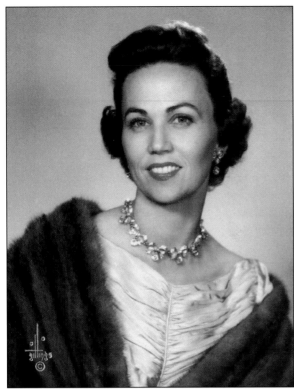

Helen Whittenburg McCartt is a member of the Texas Panhandle Whittenburg ranching family. She married grocer Eugene J. McCartt Jr. in 1939 and made the Wolflin Historic District her home for many years. (Portrait by Giddings; courtesy of Joseph Robert "Joe Bob" McCartt.)

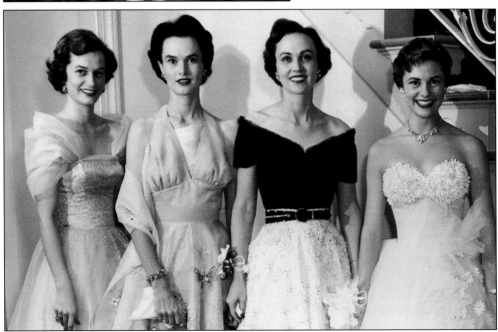

The 1954 wedding announcement party of Nancy Windsor took place at the home of Helen McCartt on Oldham Circle. Posing in front of the staircase of the home are, from left to right, Claire Windsor Snead, Deanie Windsor, Helen McCartt, and Nancy Windsor. (Courtesy of Joseph Robert "Joe Bob" McCartt.)

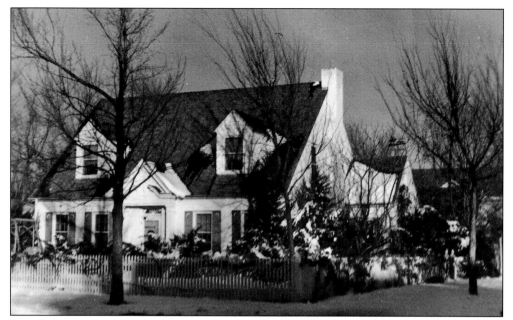

The Tudor Revival–style childhood home of A. C. "Bub" Smith at 2121 Hayden Street was built in Wolflin Place in 1935. Smith's father, O. Dale Smith, was an Amarillo oil and gas businessman who had revenue from his oil and gas leases throughout the Depression. That revenue enabled him to construct one of the only homes built in the area during the Depression. (Courtesy of A. C. "Bub" Smith.)

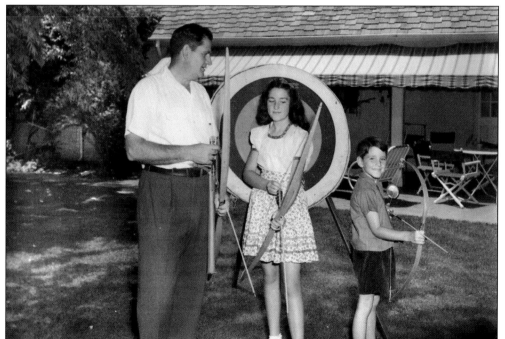

This 1940s photograph was taken in the backyard of the Smith home at 2121 Hayden Street. Enjoying a day of archery are, from left to right, oilman O. Dale Smith, his daughter Claire, and his son A. C. "Bub." (Courtesy of A. C. "Bub" Smith.)

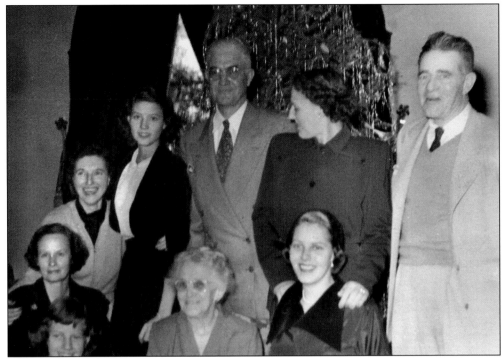

The Wolflin family celebrated a late-1940s Christmas at 35 Oldham Circle. Pictured from left to right are (first row) Fain Wolflin, Alpha E. Wolflin, and Nancy Puckett; (second row) Grace Fain Wolflin, Cornelia Patton, Gretchen Wolflin, Charles A. Wolflin, Lela Puckett, and Cedar Puckett. (Courtesy of A. C. "Bub" Smith.)

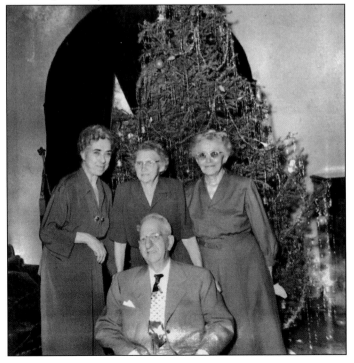

This late-1940s picture was taken at the historic Frank Wolflin home on Oldham Circle. Posing in front of the Christmas tree are, from left to right, (first row) Frank Wolflin; (second row) Daisy Currie "Grango," Orlena T. Wolflin, and Alpha E. Wolflin. Daisy Currie was the wife of Scottish native Tom Currie and the daughter of Potter County pioneer judge Nathan C. Martin. (Courtesy of A. C. "Bub" Smith.)

Seen in this 1940s photograph are, from left to right, Gene Howe, Carl Hare Sr., and Ross Rogers. Hare moved to the Wolflin Historic District in 1929 and lived there for many years. He was the owner, president, and general manager of Nunn Electric. He acquired an interest in Nunn Electric in 1926 and operated the successful company until his death in 1965. (Courtesy of the Amarillo Public Library.)

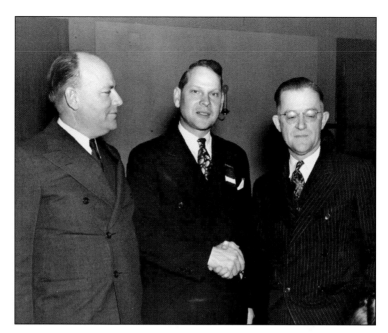

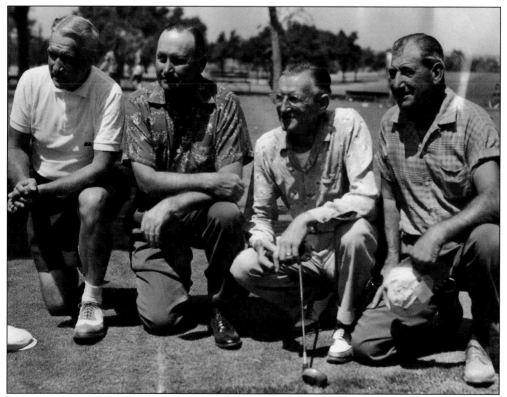

Edward "Eddie" B. Johnson Jr. was a lifelong golfer. He played in and won tournaments at various courses in Amarillo in the late 1920s and 1930s. As a Wolflin Place resident, he played at the Wolflin Park Golf Links. Johnson is pictured here second from the left with other members of a golf foursome. (Courtesy of Nita Johnson Griffin.)

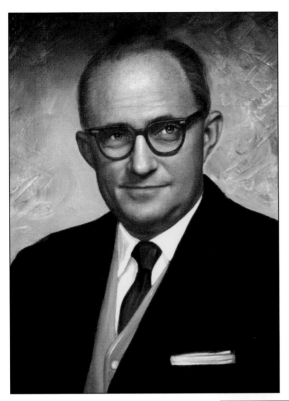

Ray Wagner established Wagner's Photography in 1945 and took many photographs of Wolflin residents. He lived in Wolflin Place at 2115 Hayden Street in a home-studio combination for a time. (Courtesy of Wagner's Photography.)

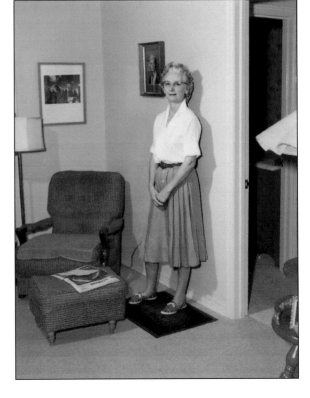

Lorine Wagner was married to photographer Ray Wagner. She is pictured here in her home, which served as a dwelling and a studio for the photography business. She helped her husband in the studio and survived her home being moved from Washington Street to Hayden Street in the 1960s. (Courtesy of Wagner's Photography.)

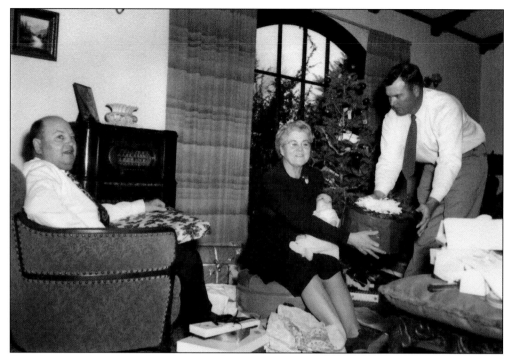

Furnishings such as the radio cabinet in this picture were typical of the 1940s. Gathered in front of the distinctive arched window in the 2815 Hughes Street home are, from left to right, O. V. Beck, Elma Beck holding Barry Beck, and David Beck. Barry Beck, born in 1945, was celebrating her first Christmas. (Courtesy of Barry Beck Jones.)

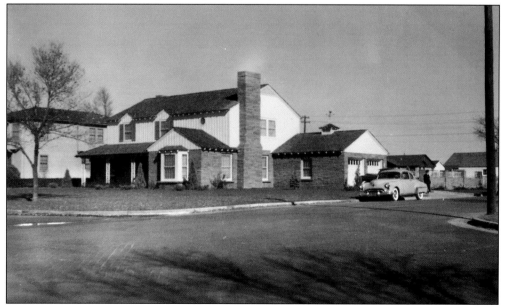

This 1950 picture is of the home Elma Beck built at 2819 Hughes Street. After her husband O. V. Beack's death, Elma built this house and lived there for several years. She eventually lived at 3009 Hughes Street until the early 1970s. Elma was an active member of First Baptist Church and served on the committee that selected Dr. Winfred Moore as pastor. (Courtesy of Barry Beck Jones.)

Amarillo Globe News society columnist Minnis "Birdie" Hall said, "The postwar world brought back lovely parties at which Amarillo wears its best clothes and brightest smiles." Wolflin residents who belonged to the Vagabond Dance Club wore their best clothes and brightest smiles. Attending a Vagabond Dance Club Christmas dance are, from left to right, Robert Garner, Jeanne Kritser, Shelby Kritser, Mary Miles Batson, and Earnest Batson. (Courtesy of Eugene and Elaine Edwards.)

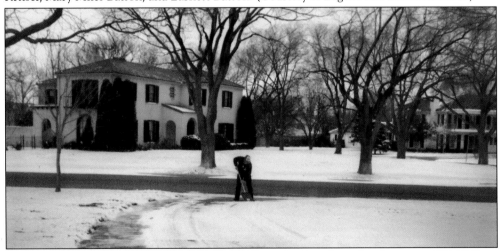

This 1965 view of 35 Oldham Circle and 34 Oldham Circle is from the driveway of 36 Oldham Circle during the time former mayor Lawrence Hagy lived in the home. Dr. Edward F. and Doris Thomas lived at 35 Oldham Circle when this picture was taken. Oldham Circle is a small community unto itself within the Wolflin Historic District. (Courtesy of the Lawrence Hagy estate.)

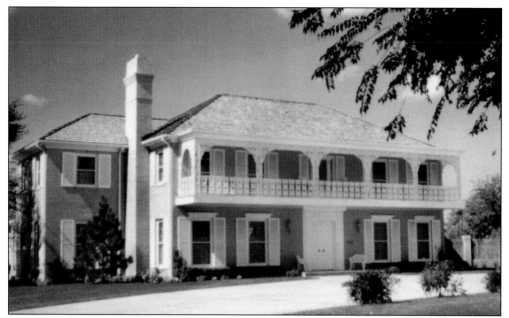

Eugene J. McCartt Jr. and Helen Whittenburg McCartt moved into the home at 34 Oldham Circle in 1952. Helen McCartt bought the lot at 34 Oldham Circle and her sister Tennessee McNaughton built a home at 3000 Parker Street adjacent to the McCartts' property. For a time there was a vacant strip of land between them, giving the large estate-like grounds a parkland appearance. (Courtesy of Robert Joseph "Joe Bob" McCartt.)

Eugene J. McCartt Jr. and his wife, Helen, entertained often at their 34 Oldham Circle home. A 1960s gathering at the home included, from left to right, Betty Bivins, Lee Bivins, Helen McCartt, Eugene J. McCartt Jr., Kathrine Kirk Wilson, Elaine Edwards, Eugene Edwards, and David Beck. (Courtesy of Joseph Robert "Joe Bob" McCartt.)

This 1963 picture is of a celebration at 34 Oldham Circle honoring Charlene Cline Marsh and Tom Marsh's wedding. Those attending are, from left to right, Tennessee Whittenburg Cline, Stanley Marsh Jr., Charles Fariss, Ann Fariss, Richard Cline, Estelle Fariss Marsh, Eugene J. McCartt Jr., Charlene Cline Marsh, and Tom Marsh. (Courtesy of Joseph Robert "Joe Bob" McCartt.)

The house at 34 Oldham Circle was the setting for a 1963 wedding shower for Charlene Cline Marsh. Guests and hostesses pictured from left to right are unidentified, Susie McCartt Douglas, unidentified, Carol McCartt, Dot Beck, Barry Beck Jones, Tennessee Cline, Catherine Cline, and Helen McCartt, with Patti Morris seated at the table. (Courtesy of Joseph Robert "Joe Bob" McCartt.)

94

Stanley Marsh 3, grandson of oil and gas pioneer Stanley Marsh Sr., was born in 1938 in a rented house at 2120 Hayden Street and later lived in the 2600 block of Hughes Street. His family lived at 3009 Ong Street in the 1940s when, according to his brother Michael Marsh, they could see prairie to the west and the brick streets went to Oldham Circle, then only out about 50 feet. (Photograph by Wyatt McSpadden; courtesy of Stanley Marsh 3.)

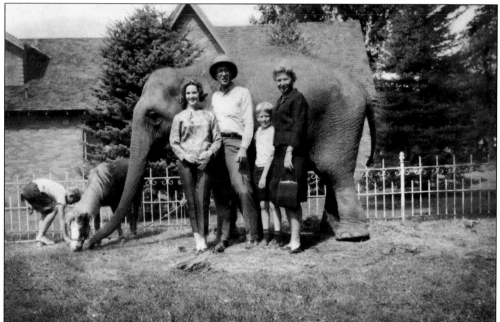

Stanley Marsh 3 sometimes brought wild animals to his home when he lived at 2406 Lipscomb Street. Standing in front of a visiting elephant in 1962 are, from left to right, unidentified, Stanley Marsh 3, Ray C. "Charles" Johnson III, and Joan Johnson. (Courtesy of R. C. "Charles" Johnson III.)

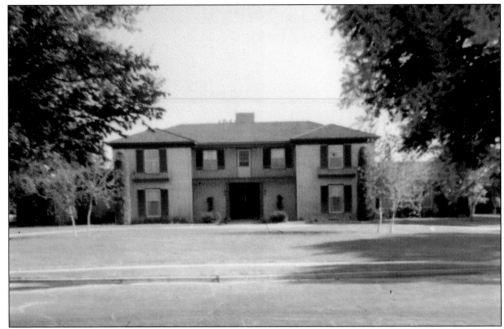

This 1965 picture shows what Lawrence Hagy's home at 36 Oldham Circle looked like soon after he moved there from 2406 Lipscomb Street. The house, built by Delmer Barnett in 1949, was originally numbered as 3200 Lipscomb Street for a number of years. (Courtesy of the Lawrence Hagy estate.)

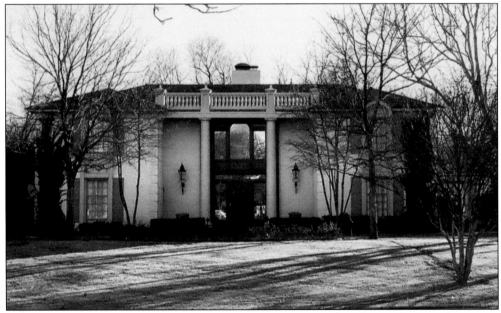

Greek Revival–style features have been added to the 36 Oldham Circle home of Jerry and Margaret Hodge. In June 2008, an adjacent property was being excavated for an addition to the Hodge home and a cache of 300 mint-condition Morgan silver dollars from 1887 was discovered buried in the yard. Speculation was rampant as to who buried the coins, but the details may never be revealed. (Photograph by Christine Wyly.)

Several Wolflin residents attended a 60th birthday party in 1984 for Gene Edwards at Betty Bivins's home. The surprise party had guests including, from left to right, (first row) Abbie Madden, Sybil Harrington, Imogene Taylor, and Nita Cash; (second row) Virginia Maynard and former mayor Lawrence Hagy. (Courtesy of Gene and Elaine Johnson.)

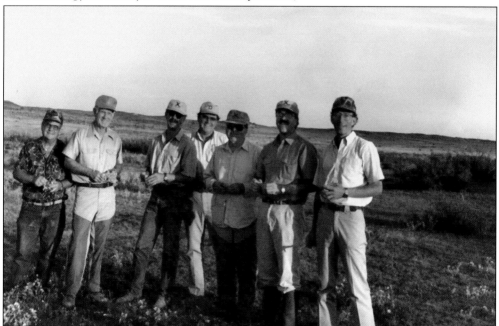

Hunting on area ranches is a traditional way to entertain out-of-town guests, conduct business, and relax from busy work schedules. This group of Wolflin residents gathered at Miles Childers's LX Ranch in 1989 for a hunt. From left to right are Bill McFarland, Gene Edwards, Teel Bivins, Bub Smith, Fred Hancock, Tom Bivins, and Mark Bivins. (Courtesy of Gene and Elaine Edwards.)

Wolflin residents (from left to right) Mark Bivins, Miles Bivins, Miles Teel Bivins, Ellen Bivins, and Emily Bivins posed for a picture in Austin, Texas, at the state capitol building. Miles Teel Bivins was serving in the Texas Senate representing the 31st District. (Courtesy of Mark and Ellen Bivins.)

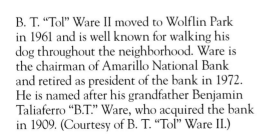

B. T. "Tol" Ware II moved to Wolflin Park in 1961 and is well known for walking his dog throughout the neighborhood. Ware is the chairman of Amarillo National Bank and retired as president of the bank in 1972. He is named after his grandfather Benjamin Taliaferro "B.T." Ware, who acquired the bank in 1909. (Courtesy of B. T. "Tol" Ware II.)

Six

OIL AND GAS PIONEERS AND RANCHERS

Ranching and the oil and gas industry on the High Plains have been intrinsically entwined from the early 20th century. Both the petroleum industry and ranching and farming have inherent risks; gambling is a normal operating procedure. The ranching families of the Texas Panhandle were among the first who saw promise in the windswept prairie. Through dust storms, drought, tornadoes, and wars they rode, roped, and branded, and for some the gamble paid off. The courage and determination of those early ranching families during the rough and tumble days has evolved into the businesslike activity of modern cattle production, still employing many and feeding multitudes. The farmers plowed the native buffalo grass, fought the mesquite, and turned the land into the breadbasket of the world. Millions of tons of wheat, milo, corn, and other crops are shipped from the Texas Panhandle every year.

As luck or providence would have it, thousands of acres of farm and ranch land in the Texas Panhandle sit atop the greatest natural gas field in the world and one of the largest oil fields. Those farmers and ranchers who had the opportunity to be the first in the region to select their slice of High Plains ranch land were the ones who hit the jackpot. The first natural gas well was completed in 1918 on the Masterson ranch, and the first oil well was drilled on the Burnett ranch in 1921. Those and other discoveries paved the way for many ranchers to have income during the Depression, hold on to their ranches, and guarantee income to their heirs for generations. The oil and gas industry still employs thousands of people in the region today, contributing millions of dollars to the local economy.

Often ranchers and oilmen had homes out on the prairie and grand townhomes in the Wolflin Historic District. Today many descendants of those pioneer ranching families still live there. Those who dwell in them have made philanthropic contributions to the Texas Panhandle in the areas of fine arts and public service that have enriched the lives of all who live there.

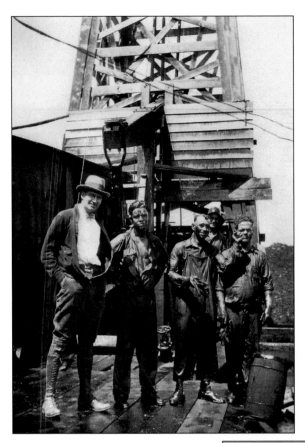

Chicagoan O. Dale Smith came to Amarillo as a geologist for Sinclair Oil and made friends with early oilmen Cedar Puckett, Lawrence Hagy, and Don Harrington. In partnership with the Currie family, Smith began exploration east of Borger, drilling a discovery well on the Harvey ranch around 1930. He is pictured here on the left with an oil-drenched crew after an oil strike. (Courtesy of A. C. "Bub" Smith.)

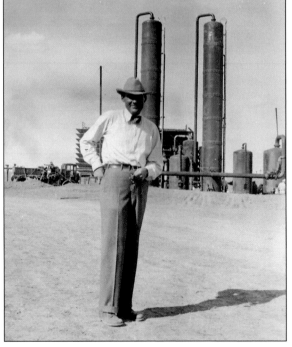

Lawrence Hagy lived in the Wolflin Historic District for many years. In this 1933 photograph, taken in Carson County, Hagy stands in front of the Cargray Plant constructed that year. His friendship with Donald D. Harrington and Stanley Marsh Sr. led to the formation of a legendary oil and gas firm. (Courtesy of the Lawrence Hagy estate.)

This 1950s photograph includes owners, board members, and employees of Baker and Taylor Drilling Company. Posing from left to right are (first row) Roy Bulls, A. M. Putnam, Fred Jones, J. C. Jackson, A. F. Webster, D. E. Spoonemore, W. W. Carter, W. H. Baker, Jack Simmons, L. R. Bigham, and Jay Taylor; (second row) E. W. Woods, E. J. Loke, and Max Banks. (Courtesy of Nita Johnson Griffin.)

Stanley Marsh 3 and Gwendolyn "Wendy" Marsh are descendents of ranching and oil and gas families. Stanley is the grandson of Stanley Marsh Sr., who was a land man for the Hagy, Harrington, and Marsh Oil Company and was born and raised in the Wolflin additions. Wendy is the granddaughter of William H. Bush, who operated the famous Frying Pan Ranch. (Photograph by Gray's Studios; courtesy of Stanley Marsh 3.)

Wolflin resident and oilman O. V. Beck drilled oil wells in various Texas Panhandle counties. Oil and gas exploration kept men in the area employed during the Depression. The Matador Well is pictured here as the crude oil started flowing in 1935. (Courtesy of Barry Beck Jones.)

The 1935 Matador Well, drilled by O. V. Beck, is shown in this photograph as the crude oil spewed to the top of the derrick on the day "black gold" was struck. Beck took part in the Texas Panhandle oil boom until his death in 1948. (Courtesy of Barry Beck Jones.)

O. V. Beck used oil money to buy ranch land that had been part of the famous XIT Ranch. The O. V. Beck ranch, located on the Texas–New Mexico border, raised registered Hereford cattle during Beck's lifetime. He is pictured here in 1944 walking among his cattle. The family has lived on the ranch at times and still owns the land today. (Courtesy of Barry Beck Jones.)

Oilman O. V. Beck and his wife, Elma, are pictured here in the early 1940s before his death in 1948. When he died, Elma lived in their house several years with her son David W. Beck and his family, and then she built her own home. She bravely entered the business world and learned how to run the family ranch and operate their oil and gas company. (Courtesy of Barry Beck Jones.)

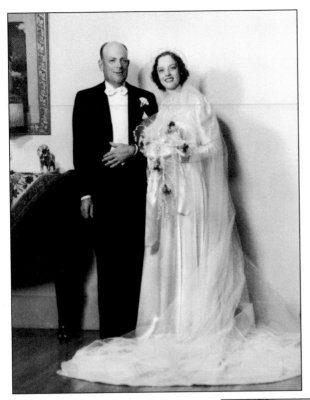

In this 1939 wedding photograph, Jeanne Howe Kritser is posing with her father, newspaper publisher Gene Howe. When Gene died in 1952, his widow, Gale Donald Howe, moved to a Wolflin home on Lipscomb Street. Jeanne, who loved fine art and world travel, moved to a home in Wolflin Estates in 1956, where she lived until her death in 2002. (Photograph by Edwards Photography; courtesy of Sloan Howe Kritser.)

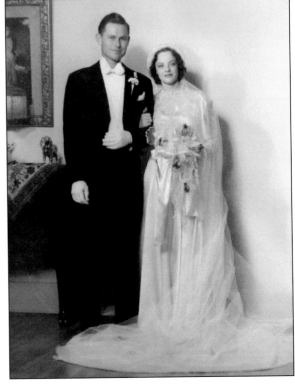

Shelby Masterson Kritser and Jeanne Howe Kritser owned the Persimmon Ranch northeast of Canadian, Texas. He was a descendent of pioneer R. B. Masterson, who owned the Masterson Ranch where the first natural gas well in the Texas Panhandle was drilled in 1918. An avid aviator, Shelby founded the Tradewind Airport and died in an air show airplane crash in 1966. (Photograph by Edwards Photography; courtesy of Sloan Howe Kritser.)

Panhandle rancher S. B. Whittenburg lived at 2038 Hayden Street during the 1930s and 1940s. While he lived in the Wolflin area he was general manager of the *Amarillo Times*. Later, in 1960, while he was publisher of the *Amarillo Globe-News*, the *Globe-News* won a Pulitzer Prize Gold Medal for Meritorious Service for the newspaper's investigative reporting on Amarillo law enforcement. (Courtesy of Thomas Whittenburg.)

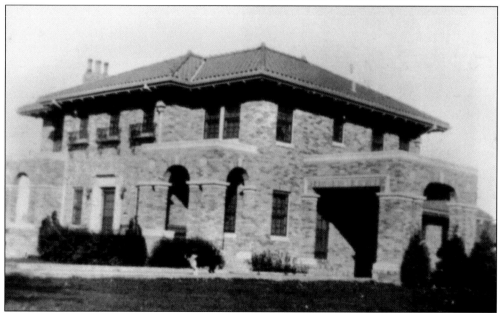

Prominent ranchers Terry and Georgie Sneed Thompson lived in this house at 3002 South Ong Street. Terry started the first significant ranch in Moore County in 1913 and invested in land in Moore County that included portions of the original town site of Dumas, Texas. Georgie was known as "Big Mother" to her family and as a woman that ruled the home with an iron hand. (Courtesy of Betty Howell.)

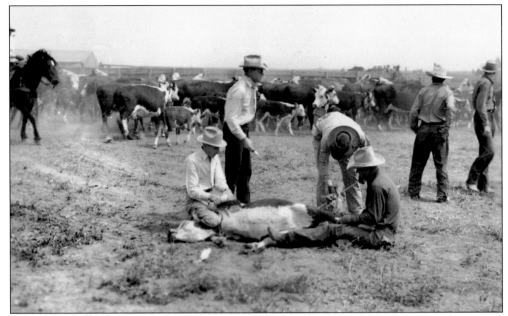

In this August 1939 picture, Jay L. Taylor is standing over three men who are branding a calf on his Double H Ranch at Magdalena, New Mexico. The origin of the Double H brand was to honor two people who were influential in his life: Earl Halliburton, who gave him his start, and his mother-in-law, Elizabeth Herring, who "staked" him in his cow operation. (Courtesy of the Amarillo Public Library.)

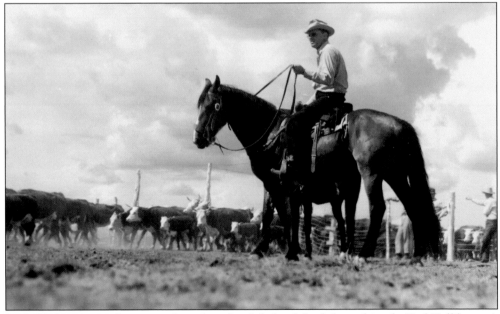

Jay L. Taylor grew up farming and ranching but left that life while working for Earl Halliburton's oil field company. He returned to ranching after he married Imogene Herring, daughter of Col. C. T. and Elizabeth Herring, and raised registered Hereford cattle on the Rafter O Ranch near Vega, Texas. They lived in a home on Hughes Street for many years. (Courtesy of the Amarillo Public Library.)

Ranchers Edward B. "Eddie" Johnson Jr. (left) and Jay L. Taylor bought the Western Stockyards in 1940. They built a sales ring, and in 1945, they incorporated the business as Amarillo Livestock Auction Company. This picture was taken in the late 1940s in Johnson's office at the Amarillo Livestock Auction as he visits with Taylor. (Courtesy of Nita Johnson Griffin.)

The Amarillo Livestock Auction received a Texas State Historical Marker in 1970. This photograph was taken as Eddie Johnson posed beside the marker the day it was erected. Johnson and Jay Taylor had purchased Western Stockyards and revolutionized cattle marketing with their operation of the Amarillo Livestock Auction. (Courtesy of Nita Johnson Griffin.)

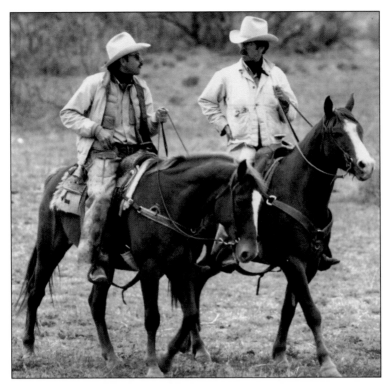

The Bivins family has ranched in the Texas Panhandle for more than a century. Lee Bivins settled in Armstrong County in 1890 and purchased 12,000 acres known as Mulberry Pasture, which may have been part of the JA Ranch. He acquired the LX brand in 1915 and founded other ranches as well. His great-grandsons Thomas P. Bivins (left) and Miles Teel Bivins are pictured here counting cattle on the XL Ranch in the 1980s. (Courtesy of Thomas P. Bivins.)

Today's ranching families continue to share their heritage with their children. In this 2003 photograph, Mark Bivins has his children Emily and Miles Bivins alongside during cattle branding on the XL Ranch. (Courtesy of Mark E. and Ellen Smith Bivins.)

Seven

COMMERCE

The Wolflin Historic District is made up of residents from all walks of life. Professionals such as architects, teachers, physicians, and lawyers, to whom the original developers marketed the first lots, make up a large portion of the population of the district. Throughout the years, affluent grocers and shopkeepers comprised a surprisingly large number of residents who lived next to the many oil and gas operators, ranchers, farmers, and bankers. Despite downturns, such as during the Depression and after the Amarillo Air Force Base closure, the wide range of occupations among the residents of the Wolflin Historic District has been an echo of Amarillo's determination to adapt and thrive.

More than a few residents of the Wolflin Historic District opened businesses in the Wolflin Village and Wolflin Square shopping centers. Initially the Wolflin Village and Wolflin Square shopping centers were on the outskirts of town when they were built in the 1950s. Business boomed until Amarillo grew southwest in the latter part of the 1900s and modern malls were built. The area has experienced a resurgence of business since 2000. Georgia Street, which borders the western edge of the Wolflin area, is thriving, and Wolflin Village and Wolflin Square are home to trendy shops and restaurants. Its upscale stores and boutiques make present-day Wolflin Village as unique a place of commerce as the adjacent Wolflin Historic District is a unique place to live.

When Wolflin lots stopped selling during the Depression, the Wolflins had difficulty paying the land mortgage to Amarillo National Bank. If not for the forbearance of the Wares, who owned the bank, the land might have been lost to foreclosure and the historical district may not have existed. Pictured here, Benjamin Taliaferro "B.T." Ware's office is likely where major decisions were made. (Courtesy of the Amarillo Public Library.)

Physicians lived near downtown in early Amarillo, but as the Wolflin area was developed, many gradually moved there. That trend continues today. This undated photograph of physicians includes Wolflin residents and those whose families eventually moved to Wolflin. They are, from left to right, (first row) Drs. Thomas F. McGee, Eli Johnston, Charles Randall, and James Wrather; (second row) Robert Killough, Isaac Rasco, George T. Vineyard, Robert Walker, Robert Gist, A. F. Lumpkin, James C. Crume, and Samuel P. Vineyard. (Courtesy of the Amarillo Public Library.)

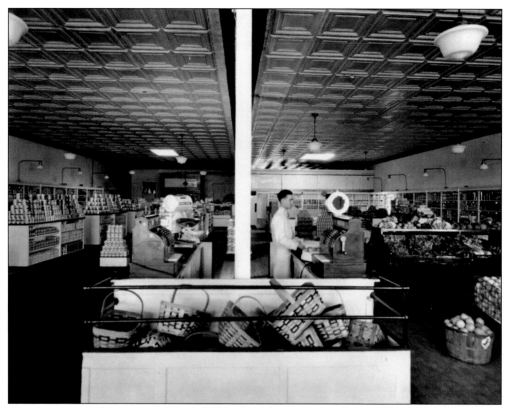

This picture is of the interior of an early Furr Food Store. Grocer Crone W. Furr, the founder, was an early resident of Wolflin Estates. He moved to Amarillo in 1927 after acquiring the rights to M System stores and soon began acquiring Piggly Wiggly stores as well. In the 1930s, he began converting the stores into what became the 130-store Furr's supermarket chain. (Courtesy of the Amarillo Public Library.)

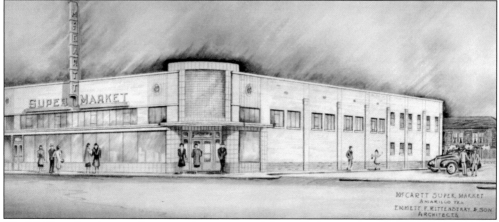

The McCartt family owned supermarkets in several Amarillo locations, including downtown and Wolflin Village. This is an architect's drawing of a new McCartt Super Market that was advertised as "having the newest ideas in design, construction, decoration, and utility installations to achieve the ultimate in customer convenience and comfort while shopping." (Courtesy of Joseph Robert "Joe Bob" McCartt.)

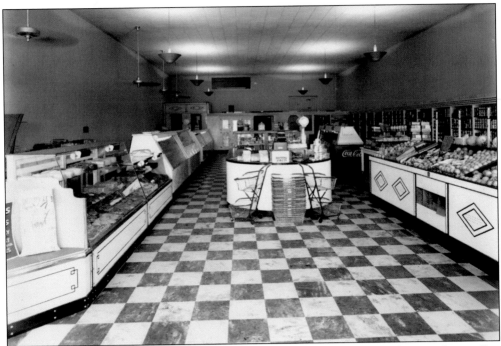

Laing Grocery Store was located in the Wolflin Historic District at 2121 Washington Street. Guy C. Laing, who came to Amarillo in 1919, actively managed the store and owned the building where it was located. (Courtesy of the Amarillo Public Library.)

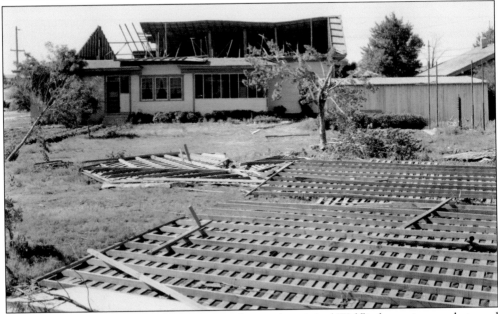

This home at 1920 South Washington Street, close to the original Wolflin homesite, was destroyed by a tornado on June 8, 1934. Handwriting on the back of the picture indicates the home may have been insured with the Williams-Boyce Insurance Company, which was founded in 1904 and continues in Amarillo. Members of the Boyce family live in the Wolflin Historic District today. (Courtesy of the Amarillo Public Library.)

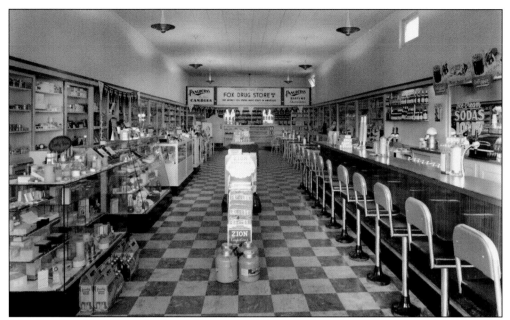

John Smithee Sr. came to the Amarillo area in 1918, worked as a drug salesman, and then became affiliated with Fox Drug. This Fox Drug Store No. 9 was located at Twenty-second Avenue and Washington Street in the Wolflin Historic District. Smithee sold the last Fox Drug Store in 1944. Today his son John Smithee Jr. lives in Wolflin and is in the Texas State Legislature. (Courtesy of the Amarillo Public Library.)

In 1952, Stanley T. Blackburn, president of Blackburn Brothers, moved to 3214 Ong Street in Wolflin Estates. This photograph of Blackburn's ladies' ready-to-wear department is at the Polk Street store. The Wolflin Village location store opened in 1958 and continued until the late 1990s. (Courtesy of the Amarillo Public Library.)

The American Hostess Entertains

Vetesk's Markets operated in several locations in and around the Wolflin Historic District. This pamphlet, distributed by the grocery store, described to homemakers of the day many aspects of gracious entertaining and housekeeping. Wolflin residents remember Vetesk's Markets as a place where meats and produce were always fresh, customer service was paramount, and specialty foods were frequently in stock. Several previous Vetesk's customers say they loved the community feel of the store and were disappointed when it closed. (Courtesy of Christine Wyly.)

May the

Cheer of this season of love

Hold our new

Resolutions

In the

Spirit of

Timeless brotherhood and goodness

VETESK'S MARKET

"Particular Foods for Particular People"

2770 Duniven Amarillo FL 6-5247

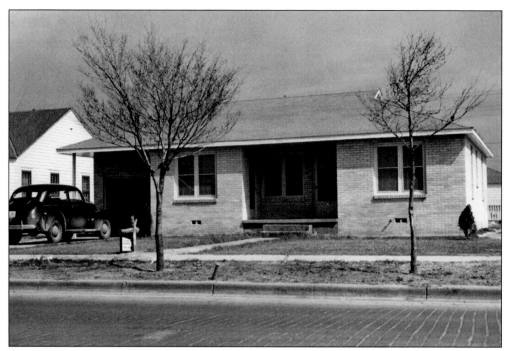

Ray Wagner's Photography Studio was located near 1900 Washington Street. It was replaced with a new building in the early 1950s that was a combination home and studio. Later, when Interstate 40 was built, the studio was in the path of the new highway. In 1963, the structure was moved to 2115 Hayden Street, where the Wagners continued to use it as a residence. Wagner had to cut the house in half to complete the move. The new studio was built in 1963 in the present-day location at the northwest corner of the Wolflin Historic District at the corner of Washington Street and Wolflin Avenue. Upon Wagner's retirement, the Crowell family purchased the business and continues to operate it today. Above is the 1950s studio and home, and below is a 1963 picture of the present building. (Both courtesy of Wagner's Photography.)

Many influential Wolflin residents served on the board of the First National Bank of Amarillo. This 1952 picture, taken at the Eighth Avenue and Tyler Street bank building, shows board members, from left to right, (seated) Lee T. Bivins, William Durham, Charles Harris, Virgil Patterson, Byron Lawrence, Dr. R. D. Gist, and Charles Fisk; (standing) Lawrence Hagy, Eugene "Gene" Edwards, Harold Dunn, Jay L. Taylor, Rip Underwood, and John Fullingim. (Courtesy of Eugene and Elaine Edwards.)

This view looking southwest across the intersection of Wolflin Avenue and Washington Street in the mid-1960s shows service stations selling gas for 32¢ per gallon. The Wolflin Drive-In, behind the Gulf station, was a popular eating establishment with Wolflin residents. In the background is the Wolflin Elementary School, which sits at the location of the original Wolflin farmhouse. (Courtesy of Wagner's Photography.)

Eight

PUBLIC SERVICE

The volunteerism of Wolflin residents is a dramatic aspect of the character of the area. Longtime residents say that, in the early days of Amarillo, there was a sense of cohesiveness and a volunteer spirit. They also relate that prior to the introduction of income tax, when there was a large amount of oil and gas money, people put cash back into the community. That mind-set continues today; in Amarillo, philanthropy is prevalent and expected. Much of the social activity in the Wolflin Historic District is centered on fund-raising and various other charitable activities.

In addition to charitable endeavors, Wolflin area residents have made major contributions of public service to Amarillo, the State of Texas, and the nation. Almost every mayor of Amarillo since the 1920s has lived in the Wolflin Historic District. The current mayor of Amarillo, Debra McCartt, lives at the edge of the district in Wolflin Park with her husband, Joe Bob McCartt, who was raised on Oldham Circle. She is the first woman elected to the mayoral position. The Wolflin Historic District has sent many people to the Texas state capitol, Washington, D.C., and foreign countries as elected and appointed officials.

Military service among people from Amarillo is common. The city's support of the military may be in part because of the Amarillo Air Force Base, originally opened in 1942 and finally closed in 1968, which was an integral part of Amarillo's culture for many years. Numerous people who lived in the Wolflin additions worked for the government and supported the military personnel during those years. Wolflin area residents who served during World War II and other conflicts are currently active in honoring veterans and fallen military members at the Texas War Memorial and other related causes.

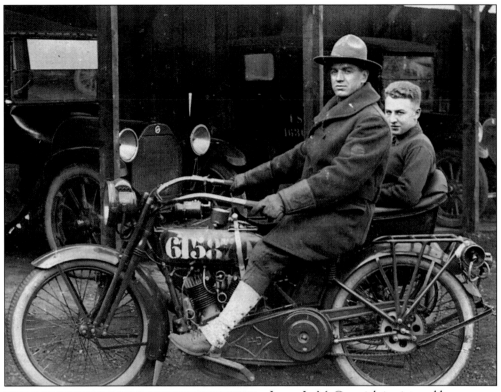

James L. McCormick is pictured here driving a sidecar with an unidentified passenger in 1918 during a World War I stint in Europe. He later founded McCormick Advertising Company in 1926 and served as the Amarillo Club's first president. He hired Dallas architect O'Neil Ford, the originator of Texas Modernism architecture, to build his unique home at 2801 Hughes Street. (Courtesy of Ray C. "Charles" Johnson III.)

This U.S. Navy ROTC portrait of Eugene "Gene" Edwards was taken in 1941 at the University of Oklahoma. Edwards served in the U.S. Navy on the USS *Pickaway* in the South Pacific during World War II. He went to work for Virgil Patterson at the First National Bank of Amarillo in 1949, where he worked for 37 years, eventually becoming CEO in 1969. (Courtesy of Eugene and Elaine Edwards)

Eugene J. McCartt Jr. and Helen Whittenburg McCartt had not been married long when World War II started. Like many other young men who answered the call and left their families to serve in the military, Eugene served in the U.S. Army. He is shown at right posing in his uniform with Helen in the early 1940s. The picture below was taken in Paris while he served overseas. McCartt returned to Amarillo after the war and worked in the family grocery business. Later he would go into the oil and gas business with T. Boone Pickens. (Both courtesy of Joseph Robert "Joe Bob" McCartt.)

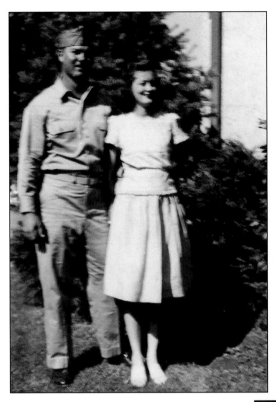

This picture of David Beck and his wife, Dorcus Dean "Dot" Beck, was taken toward the end of World War II. He served with the U.S. Army in the South Pacific and was home on furlough when this photograph was taken. When he left the army and returned to Amarillo, he worked in the family ranching and oil field businesses. (Courtesy of Barry Beck Jones.)

This picture of Jay L. Taylor was taken in Washington, D.C., on June 23, 1942, the day he was inducted into the U.S. Army. He joined as a petroleum specialist and was in charge of furnishing oil and gasoline to the army around the world. He visited every fighting front during World War II and was awarded the Legion of Merit for his outstanding service. (Courtesy of the Amarillo Public Library.)

Pictured here in 1935 are, from left to right, Texas governor James V. Allred, Lawrence Hagy, and Elliot Roosevelt, who was the son of Pres. Franklin D. Roosevelt. Governor Allred worked to limit federal involvement in the petroleum production industry, which would have interested Hagy very much. (Courtesy of the Lawrence Hagy estate.)

When U.S. president Franklin D. Roosevelt visited Amarillo on July 11, 1938, Lawrence Hagy was the driver who transported him from the train station to Elwood Park, where President Roosevelt gave a speech about water use and soil conservation. Seated in the car are, from left to right, Pres. Franklin D. Roosevelt, Mayor Ross Rogers, Gov. James V. Allred, and Lawrence Hagy at the wheel. (Courtesy of the Lawrence Hagy estate.)

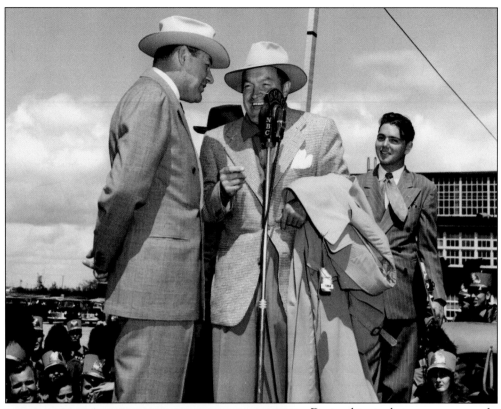

During his single term as mayor of Amarillo, Lawrence Hagy had the pleasurable duty of introducing Bob Hope to Amarillo in May 1947. In this picture, Hagy (left) is shown on stage beside Hope with a band and the Amarillo International Airport in the background. (Courtesy of the Lawrence Hagy estate.)

Eugene Klein served as mayor of Amarillo from 1949 to 1953. He is shown here in 1951 introducing the U.S. Air Force Band at a concert in the Amarillo Municipal Auditorium, which was part of the official opening ceremonies for the Amarillo Air Force Base. Klein was a Wolflin resident whose son R. P. "Rick" Klein also served as mayor of Amarillo in later years. (Courtesy of the Amarillo Public Library.)

This 1956 photograph, taken in Amarillo, shows, from left to right, visiting governor Robert A. Shivers, Virgil Patterson, and Lawrence Hagy. Patterson, who purchased the Wolflin Estates home of C. W. Furr at 3006 Hughes Street, was the CEO of the First National Bank of Amarillo, and Governor Shivers was also involved with a number of banks in Texas. (Courtesy of the Lawrence Hagy estate.)

Oldham Circle resident Jerry Hodge is pictured here as he appeared while serving as the youngest elected mayor of Amarillo from 1977 to 1981. Hodge is a businessman who owns nationwide pharmaceutical companies and the High Card Ranch near Clarendon, Texas, where he runs a longhorn cattle herd. He has served on the Texas Board of Criminal Justice and other statewide boards. (Courtesy of Jerry Hodge.)

Rep. John Smithee Jr. spent part of his childhood living at 2213 Ong Street, moved away, and then returned after law school to live in the Wolflin Historic District again. Smithee, a member of the Texas House of Representatives since 1985 representing the 86th District, is shown here at the podium in the House Chamber at the Texas state capitol in the mid-1980s. (Courtesy of John Smithee Jr.)

When then U.S. vice president George H. W. Bush spoke to the Texas State Legislature in 1985, Rep. John Smithee was on the escort committee during Bush's visit. Smithee is pictured here greeting the vice president. He remembers Bush as a gracious man. (Courtesy Rep. John Smithee Jr.)

Wolflin residents serve on many philanthropic boards in Amarillo. This picture of board members of the Harrington Foundation shows the dedication of the attendees, as there were several inches of snow on the ground that day. Wolflin residents and others present are, from left to right, Wales Madden Jr., Eugene Edwards, Sybil Harrington, Avery Rush Jr., and T. L. Roach Jr. (Courtesy of Eugene and Elaine Edwards.)

Miles Teel Bivins served five terms as a state senator in the Texas legislature. He was appointed U.S. ambassador to Sweden by U.S. president George W. Bush in 2004. This occasion was a dinner the night before he was first sworn in as a Texas state senator in 1989. Pictured from left to right are Miles Teel Bivins, Elaine Edwards, Eugene Edwards, and Nancy Terrill Bivins. (Courtesy of Eugene and Elaine Edwards.)

Texas state senator Miles Teel Bivins and Rep. John Smithee, both Wolflin residents, are pictured here in the 1980s during a ceremony to honor several World War I veterans. The function took place at what is now the Thomas E. Creek Department of Veterans Affairs Medical Center in Amarillo. (Courtesy of Rep. John Smithee Jr.)

Wolflin area resident W. H. "Bill" Juett was Potter County Republican chairman for 18 years. His wife, Jane Juett, is still active in the politics and served on the Governor's Commission for Women and the Texas Economic Development Corporation. Posing at the Texas state capitol in 1995 are, from left to right, W. H. "Bill" Juett, Gov. George W. Bush, and Jane Flesher Juett. (Courtesy of Jane Flesher Juett.)

Bill Juett was active in political, civic, and charitable causes. He served as a Boy Scout leader and was on the Amarillo Planning and Zoning Commission and the Potter-Randall Appraisal District board of directors. He was elected to the Electoral College for the 2000 presidential election. In this 2000 picture, Juett visited with Sen. Kay Bailey Hutchinson at a fund-raising breakfast. (Courtesy of Jane Flesher Juett.)

DISCOVER THOUSANDS OF LOCAL HISTORY BOOKS FEATURING MILLIONS OF VINTAGE IMAGES

Arcadia Publishing, the leading local history publisher in the United States, is committed to making history accessible and meaningful through publishing books that celebrate and preserve the heritage of America's people and places.

Find more books like this at
www.arcadiapublishing.com

Search for your hometown history, your old stomping grounds, and even your favorite sports team.

Consistent with our mission to preserve history on a local level, this book was printed in South Carolina on American-made paper and manufactured entirely in the United States. Products carrying the accredited Forest Stewardship Council (FSC) label are printed on 100 percent FSC-certified paper.

MADE IN THE
USA